CUBISM

CUBISM

Philip Cooper

Phaidon Press Limited
Regent's Wharf, All Saints Street, London N1 9PA

Phaidon Press Inc.
180 Varick Street, New York, NY 10014

www.phaidon.com

First published 1995
Reprinted 1996, 1998, 1999, 2001, 2002, 2003
© 1995 Phaidon Press Limited

ISBN 0 7148 3250 2

A CIP catalogue record for this book is available from the
British Library

Printed in Singapore

The publishers would like to thank all those museum authorities and
private owners who have kindly allowed works in their possession to
be reproduced.

Note: All dimensions of works are given height before width.
These symbols on the pages facing the colour plates indicate the
orientation of the work.

↑ ←

Cover illustrations:
Front: PABLO PICASSO, *Bottle of Vieux Marc, Glass, Guitar and
Newspaper*, 1913 (Plate 23)
Back: STUART DAVIS, *Lucky Strike*, 1921 (Plate 45)

Cubism

In the summer of 1906 the Spanish artist Pablo Picasso (1881–1973) was at work in the small village of Gósol in Catalonia, and it was there that he first conceived what was to be a turning point in his art. Following his return to Paris, in 1907 he painted the huge canvas *Les Demoiselles d'Avignon* (Plate 3). Both his laborious preparation for it and its large scale indicate that he wished it to be a masterpiece, and posterity has confirmed it so. The painting represents not only a radical new phase in Picasso's art but the beginning of truly Modern art. It is also the first Cubist work. Five awkwardly posed nudes confront the viewer, their bodies fragmented into angular shards, their mask-like faces gazing directly outwards. Its aggressive manner and distorted forms shocked those few to whom it was shown in Picasso's studio. The artist's friend, the American writer Gertrude Stein, wrote of it thus: 'little by little there came the picture *Les Demoiselles d'Avignon* and when there was that it was too awful.' The Russian collector Sergei Shchukin, who had admired Picasso's earlier work, apparently wept on seeing the painting, claiming that the Spaniard's new departure was a great loss for French art. Even avant-garde artists were baffled: Henri Matisse (1869–1954) thought it a mockery of Modern art and purportedly vowed to make the artist pay for such an outrage.

So, amid tears and indignation, the most revolutionary of modern movements was born. Cubism constituted the greatest upheaval in art since the Renaissance. The artist was no longer obliged to depict objects naturalistically but was also influenced by his mental conception of them. Traditional perspective was abandoned and objects were often splayed out to show them from several viewpoints, and only a few defining details might be included: for example, a button to indicate clothing, or a moustache to suggest a man's head. Further, greater freedom was allowed than before in manipulating the subject-matter to unify the composition; the elements in a picture might be chosen and placed purely according to aesthetic considerations rather than being firmly based in reality.

Historically, Cubism grew out of the preceding movements of Symbolism, Post-Impressionism and Impressionism, each of which questioned Renaissance assumptions about art. The Impressionists wished to capture only fleeting images of the world as it was perceived by the artist. Post-Impressionism was more subjective, and artists such as Paul Gauguin (1848–1903) and Vincent van Gogh (1853–90) allowed themselves to be guided by their emotions just as much as by the scene before them. They also began to realize the absurdity of the naturalistic demand that a flat surface should ape the solid world. This is expressed by Maurice Denis (1870–1943) in his famous quote of 1890: 'Remember that a painting, before it turns into a war horse, nude woman or whatever, is essentially a flat surface covered by colours which have been organized in a particular order.' The Symbolists rejected appearances altogether in favour of a 'real' world behind

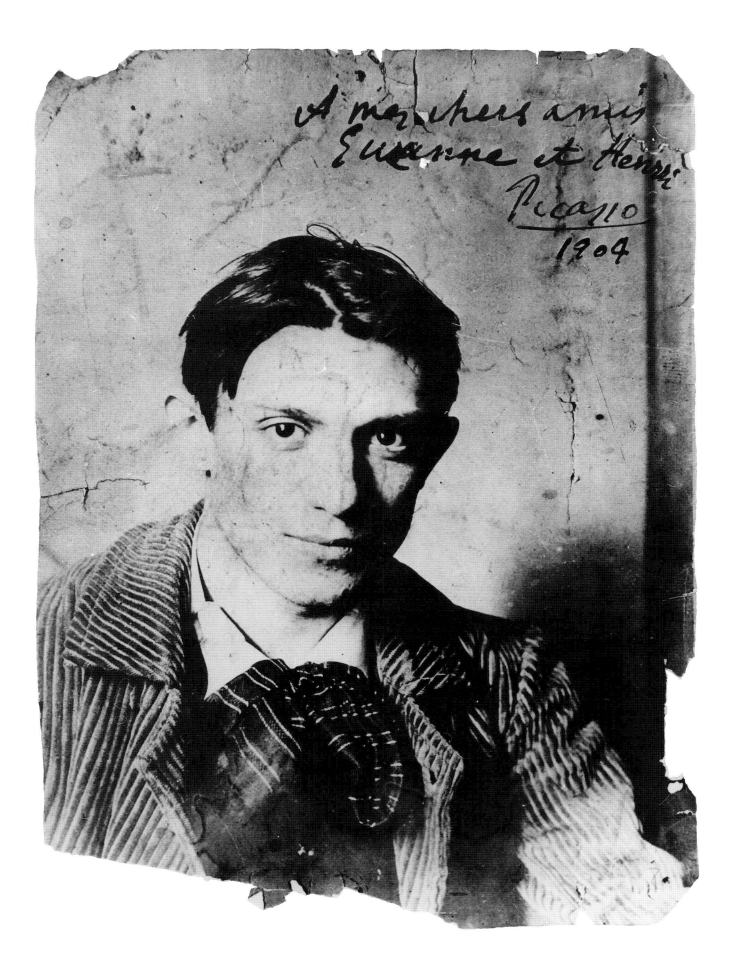

A mes chers amis
Suzanne et Henri
Picasso
1904

them or a world of dreams.

Most important to the development of Cubism, however, was Paul Cézanne (1839–1906). Like the Impressionists, he too wanted to depict nature, but where they saw only the transient he perceived rigorous, invariant structures. These had to be reflected in painting, leading to his dictum that 'Nature should be treated as cylinders, spheres and cones.' In his later landscape works (see Plate 2), this conviction led him to fragment scenes into facets of colour. As a result, they have an unusual two-dimensionality: colour planes from the foreground merge with those of the background (what is called 'passage') and so flatten the space. In his still lifes and interiors (Plate 1 and Fig. 14) even elements such as table-cloths are rendered as if rigid so as to add structure to the composition. Defying the rules of perspective, tables, cups and other objects are tilted towards the picture plane, so that the painting effectively combines more than one viewpoint.

Cézanne also emphasized the interpretative role of the artist: one cannot and should not merely try to copy nature, since 'Art is a harmony parallel to Nature.' Despite its originality, Cézanne's art was almost ignored until his last years. He began to achieve great fame by the early twentieth century and in 1907, the year after his death, two large-scale exhibitions of his work were held. Another artist who interested the Cubists was the amateur painter Henri Rousseau (1844–1910), known as 'le Douanier' (the customs officer). He produced naïve images of exotic subjects. His primitive style further expanded the scope of artistic freedom, while his touchingly inflated self-esteem led him to make the bizarre comment to Picasso: 'You and I are the greatest painters of our time, you in the Egyptian style, I in the modern.'

From its beginnings in Paris, Cubism rapidly spread all over the world and, though initially confined to two-dimensional works, it soon influenced sculpture and design. In less than ten years the ground had been layed for much subsequent twentieth-century art. Many artistic developments that followed were extensions of ideas and techniques that Cubism had pioneered: for example, Abstract art is implicit in Cubist painting, Conceptual art is evident in its verbal and formal play, the inclusion of mass-produced objects in collages and *papiers collés* (images that incorporate fragments of pasted paper) presages Pop art, while the 'ready-mades' of Marcel Duchamp (1887–1968) and the processes of assemblage are intimated in Cubist sculpture.

In each country and in the work of almost each artist, Cubism assumed a unique form. Its diversity is evident even in its early development in Paris, where it took two distinct forms. The first and most important is that centred on the Montmartre district of Paris, where Picasso (Fig. 1), Georges Braque (1882–1963) and later Juan Gris (1887–1927) as well as the poets Guillaume Apollinaire, Max Jacob and André Salmon lived and worked. A second, more public manifestation is represented by the so-called Salon Cubists, who included Jean Metzinger (1883–1956), Albert Gleizes (1881–1953), Robert Delaunay (1885–1941) and Fernand Léger (1881–1955), these last two being somewhat independent. Nevertheless, broadly common characteristics can be discerned: the typical Cubist picture lacks perspective and employs geometric forms, restricted colour and a liberal manipulation of visual appearances.

At first sight this style seems wilfully perverse, an inexplicable subversion of artistic tradition, yet, as Gris stated in 1925, Cubism was 'connected with every manifestation of contemporary thought'. At the beginning of the twentieth century the perception and experience of

the world was in a period of rapid change. As scientists such as Albert Einstein quietly overturned the traditional view of the universe, technological developments like radio communication, powered flight and the petrol engine had an immediate, public impact, making distances seem smaller and time more concentrated. Wild speculation was rife and there were attempts to investigate the possibility of communication with Mars and even to discover the weight of the human soul. Philosophers, too, were forging new visions of the world: the Frenchman Henri Bergson suggested that intuition, rather than reason, was the proper means for attaining understanding. Central to his thought is the concept of duration, the indivisible, mental experience of time, which he opposed to the artificial, segmented definition of it used by science. According to him, the whole stream of time is simultaneously active in the human mind; psychologically, the past impinges on the present through memory, while the future enters the present through anticipation.

Despite this cultural turmoil the dominant framework of painting remained that established during the Renaissance. The basis of this was the study of visible reality: solid objects were recreated on a two-dimensional surface using the deceits of single-point perspective, chiaroscuro and modelling. As a result, the viewer was made to think that when in front of a canvas he was looking out onto the world, however transformed by the artist's imagination. It was the Cubists who fully realized that the naturalistic, Renaissance conception of art was only one possibility among many. A man, for example, might be depicted as in a painting by Raphael (1483–1520), as in the 'stick' drawing of a child, or even by the word 'man'. The fact that the Raphael looks most like the real thing is not, in itself, evidence of its superiority. Furthermore, in earlier times and in other cultures, artistic conventions had been radically different. Feeling the Renaissance aesthetic to be exhausted, the Cubists therefore developed a whole new way of creating pictures that was informed by contemporary trends.

One important feature of Cubism is the enhanced expressive role given to the formal qualities of a painting. In many works objects lack spatial integrity and merge with those around them, and this device can be broadly related to the perceived compression of time and space created by the new forms of communication. More specifically, it is a response to the theory of 'Simultaneity' proposed by the Salon Cubists, which held that events and objects are inextricably interconnected in time and space. Drawing on Bergson's philosophy, these ideas grew partly out of the associations formed by such figures as Gleizes and the poets Henri-Martin Barzun and Alexandre Mercereau, who had been part of the idealistic community, called the Abbaye de Créteil (1906–8). A variant of Simultanism was Unanimism as propounded by the writer Jules Romains, who had been an associate of the Abbaye de Créteil. In a similar fashion, Unanimism asserted that the individual could become absorbed into the collective spirit of a group. The Cubist rejection of the single, static viewpoint and its violation of the closed contours of an object can thus be seen as a way of accounting for this Simultanist/Unanimist view of the world. By contrast, naturalism generally focuses on one instant of time in which objects are caught, frozen and distinct.

Cubist works are broadly geometrical in appearance, reflecting the widespread fascination with mathematics among the artists. In the important book, *On Cubism* (1912), by Gleizes and Metzinger, non-Euclidean geometry is mentioned, while the Montmartre circle included the amateur mathematician Maurice Princet. Even Picasso,

not greatly interested in theories, is reported to have carried around the books of the mathematician Henri Poincaré. He is also said to have often spoken of the fourth dimension, a concept that had much currency at the time. Though precisely defined by mathematicians, it suggested to others that there was a mystical 'extra' dimension behind the everyday world, one that was more significant than the three of ordinary experience. It has thus been claimed that the Cubist style formed part of an attempt to capture this elusive quantity in art.

The purported metaphysical aspect to Cubism was also crucial to Symbolism. Though a product of the nineteenth century and based around a mystical, idealist philosophy, Symbolism has surprising affinities with Cubism, and many of the Cubists had grown up in its shadow. Picasso, and occasionally Braque, used to attend the literary gatherings at the Closerie des Lilas café, where Symbolist writers such as Jean Moréas could be found. The most prominent of the Symbolist poets, Stéphane Mallarmé, once stated that 'to name an object is to suppress three-quarters of the enjoyment of a poem which consists in the pleasure of discovering things little by little: suggestion that is the dream.' Similarly, in some Cubist works objects are hinted at rather than depicted. In addition, Apollinaire and Jacob were, like the Symbolists, interested in the occult, which is constructed around arcane symbols in the same way as Cubism can seem to be.

The difficulty in reading Cubist works highlights one of their central ambiguities: whether or not their aim is to represent reality, or even to represent anything at all. The problem is suggested in Stein's paradoxical description in 1938 of the first beginnings of Cubism in Picasso's art: 'He commenced the long struggle not to express what he could see but not to express the things he did not see, that is to say the things everybody is certain of seeing but which they do not really see.' One interpretation of Cubism is that it allowed for a more objective image of the world, hence, for example, objects are splayed out to show them in full. Further, some critics used the idealist theories of philosophers such as Plato or Immanuel Kant to explain Cubism, claiming that it captured some timeless reality that lay behind the changing visible world. This understanding is supported by the interest in the fourth dimension and Symbolism, yet there is a strong subjective trait in both of these – one that is centred on the visionary perception of the artist. In addition, underlying Cubism is a belief that artistic images are independent of reality. Picasso emphasized this in his notorious comment: 'Art is a lie that makes us realize the truth.' This autonomy is especially apparent in Montmartre Cubism in which the compositions are deliberately manipulated to create visual and intellectual puns, and to comment on the nature of representation and reality.

If art is allowed such freedom, then perhaps it need not represent anything at all. While a painting can depict the world around us, it also forms part of that world. It is not only an image but an object in its own right, a 'picture-object', and can be appreciated as such. Thus in Montmartre Cubism, the object quality of paintings is underlined by the inclusion of real objects in the *papiers collés* and by the creation of a shallow pictorial space that draws attention to the flatness of the canvas. The seeds of non-figurative art are evident here, yet while the Cubists did introduce abstract elements into many of their paintings, they generally stopped short of total non-figuration. Indeed, subject-matter plays a significant role. This is, on the whole, clear in Salon Cubism, where the subjects are both ambitious and broadly legible, but it is less obvious in Montmartre Cubism, where the range of subjects seems limited and those that are chosen are hard to decipher.

However, even here it is richly used to make references to the everyday lives of the artists and to society at large. The general intent of Cubism doubtless varies from one artist, even from one work, to another, yet Picasso pinpointed a central theme when he said that the reality in a Cubist work is not one 'you can take in your hand. It's more like a perfume – in front of you, behind you, to the sides. The scent is everywhere but you don't quite know where it comes from.'

The historical development of Cubism was very rapid, initially evolving from the example of Picasso's *Les Demoiselles d'Avignon* (Plate 3). In this picture the influence of Cézanne is evident, but there are a number of other forces at work. One of the most important is non-Western sculpture, both Iberian (from before the Roman conquest of Spain) and African. Picasso was not alone in such interests: among others, Matisse had earlier discovered African art and may have introduced Picasso to it in 1906. All the five figures in *Les Demoiselles d'Avignon* have mask-like faces, the two on the right being particularly imitative of African sculpture. Among those to see the work was Braque, who probably first visited Picasso's studio towards the end of 1907 accompanied by Apollinaire. Despite the initial shock, he soon realized that the painting opened up a whole new path for art.

Thereafter, especially from late 1908, until 1914, Picasso and Braque worked in close contact. For several years they both lived in Montmartre, Picasso renting a studio in a dilapidated building nicknamed the Bateau Lavoir because of its resemblance to the laundry boats on the Seine. (Gris also lived in the building but had not yet taken up painting.) This period was lively and Bohemian, and Picasso remained in contact with the area even after his move to Montparnasse, on the Left Bank, in 1912. The evenings were often spent enjoying the company of artists, poets and other friends, while drinking or occasionally experimenting with drugs. (This ceased after a German painter friend, Wiegels, hung himself following an overdose in late 1908.) The group became so closely knit that, according to Salmon, there were 'countless jokes, rites and expressions that were quite unintelligible to outsiders', just as Cubism seemed to many critics.

Braque soon absorbed the lessons of *Les Demoiselles d'Avignon*, and both he and Picasso made equal contributions to Montmartre Cubism. In general, Picasso was more impulsive and often worked in several directions at once, while Braque was more hesitant and consequently less productive quantitatively. He once modestly stated that he saw Cubism as a means 'to put painting within the reach of my own gifts'. Never possessed of the same facility as Picasso, he had always to labour at his art. By contrast, Picasso had a prodigious technical ability which enabled him to paint with extraordinary ease. For him, Cubism was a great discipline, its sobriety and near abstraction very much in tension with his innate tendency towards the expressive and figurative. Early Cubism developed with such intensity that significant advances occurred in the space of months rather than years, and consequently much attention has to be given to the sequence of Picasso and Braque's works, not so much to determine questions of chronology but rather to understand the logic between successive stages.

Rejecting his earlier bright and expressive Fauve technique, at the end of 1907 Braque began to experiment with a more sculptural, Cézannesque style. Following the important *Large Nude* (Fig. 2) of 1907–8, he mostly treated landscapes at this time, focusing on features such as buildings and viaducts. These inevitably gave his works a strong, geometrical structure, as in the paintings executed at L'Estaque (Fig. 3). Like Braque, Picasso also worked in a sculptural

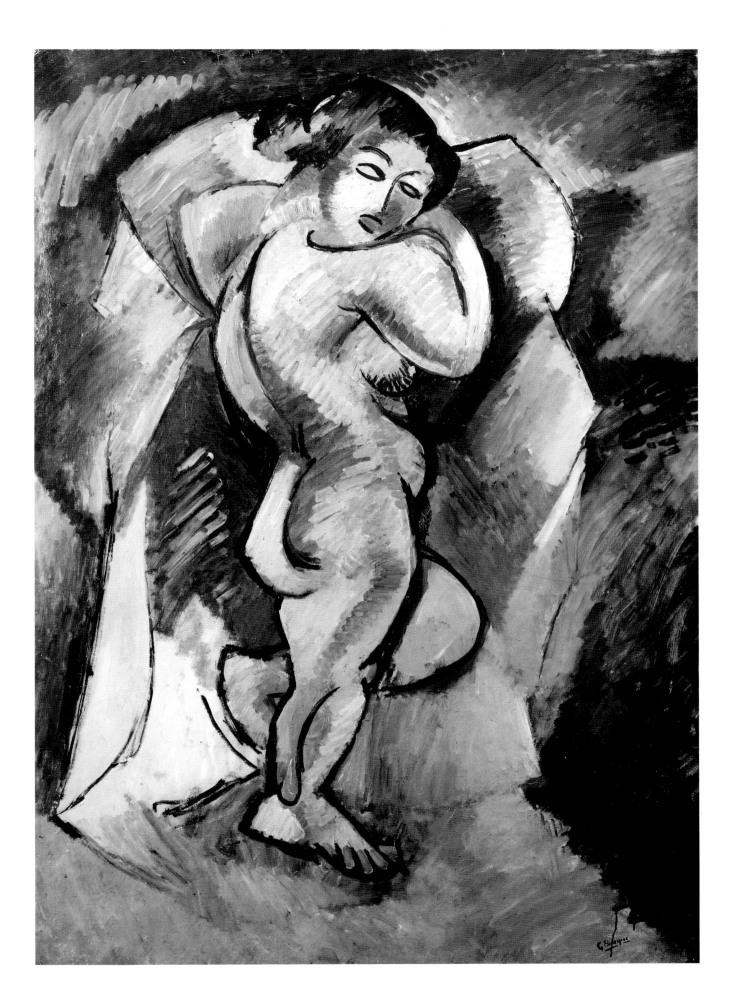

fashion: his figures, for example, look as if they are hewn from wood rather than painted (he did, in fact, carve wooden sculptures at this time). In September 1908 Braque submitted six or seven canvases to the Salon d'Automne, all of which were rejected. Among the jurors was Matisse, who was reported by Louis Vauxcelles (the critic who christened Fauvism) to have said that one of the paintings was 'made of small cubes' and this is traditionally taken to be the origin of the term 'Cubism'. The first published reference to cubes appeared a couple of months later when, speaking of Braque's one-man show at the Galerie Kahnweiler in Paris in November 1908, Vauxcelles wrote in the newspaper *Gil Blas* that the artist 'despises form, reduces everything, places and figures and houses, to geometrical schemes, to cubes'. The actual term 'Cubism' was not used until April 1909 by the critic Charles Morice. By the end of 1908 Picasso and Braque were in very close contact, working on similar subjects and problems and jointly analysing the example of Cézanne's work. Braque later said of this period that they were 'like two mountaineers roped together'.

In 1909 Braque made a trip to Le Havre and painted *Harbour in*

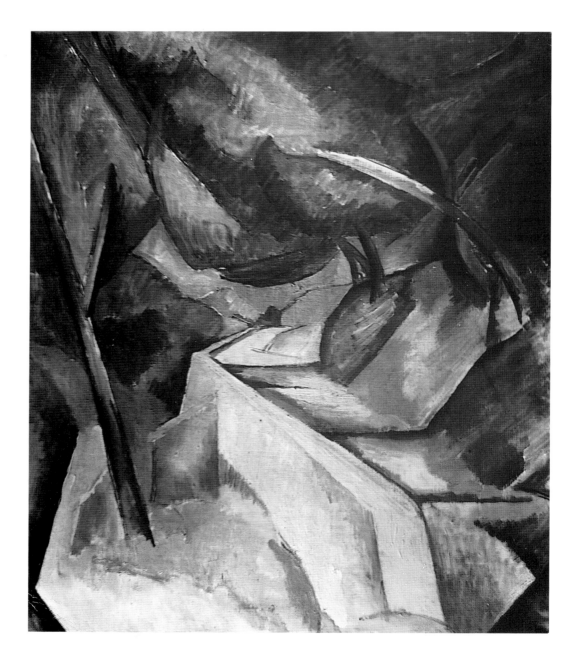

Fig. 3
GEORGES BRAQUE
Road at L'Estaque
1908. Oil on canvas,
60 x 50 cm.
Museum of Modern Art,
New York, NY

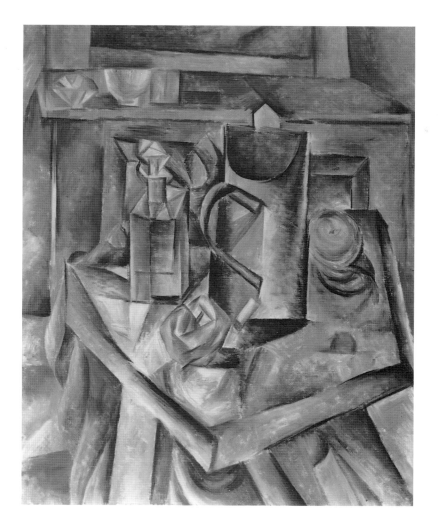

Fig. 4
PABLO PICASSO
Le Bock (Glass of
Beer)
1909. Oil on canvas,
81 x 65.5 cm.
Musée d'Art Moderne,
Villeneuve d'Ascq

Normandy (Plate 4), which shows how he had grasped the essence and potential of the Cubist technique. The objects are no longer sculptural or solid, rather they are flattened out into a highly complex pattern of planes whose modelling and colour serve aesthetic as much as descriptive ends. As would be the case for the following two years or so, the colour is restricted to a narrow range of browns and greys, formal considerations having now taken precedence. In 1909–10 he painted a series of still lifes incorporating musical instruments, in some of which he included a *trompe l'œil* nail, as in *Violin and Pitcher* (Plate 7). This apparently inconsequential detail highlights the flat, anti-naturalistic technique of the rest of the work. As it appears to be physically hammered into the canvas, it also underlines the fact that the painting is an object, not a transparent image. In this same period Braque first introduced lettering into Cubist paintings and this serves both to emphasize the picture surface (because letters have no spatial depth) and to make the point that Cubist painting, like language, relies on signs in order to communicate. In this year Braque had rather taken the lead from Picasso. The latter spent the spring and summer of 1909 in Spain, in Barcelona and Horta de Ebro (now Horta de San Juan), producing paintings that are still sculptural and three-dimensional. On his return to Paris in the autumn these qualities persisted in his paintings (see Fig. 4) and he even experimented with sculpture, producing the important *Head of a Woman (Fernande)* (Fig. 5), the first attempt to transfer Cubism into the round.

The Cubism of this date is usually called 'analytical', a label intended

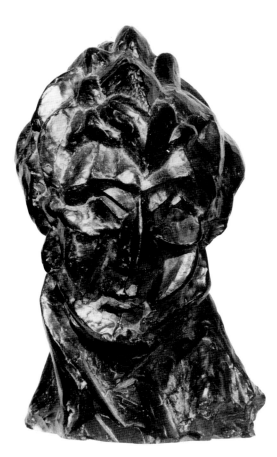

Fig. 5
PABLO PICASSO
Head of a Woman
(Fernande)
1909. Bronze, h41 cm. Art
Center, Fort Worth, TX

to describe the process of fracturing forms and then rearranging the constituent elements so that objects are splayed out and the pictorial space flattened. In the years 1910–11 Picasso and Braque extended this method so that the contours of objects were violated and elements fragmented until the resulting image is almost illegible (see Plates 8 and 10). Such works are consequently called 'hermetic' or 'high analytical'. Especially in the hermetic works, the title is meant as an important point of entry through which the viewer is able to piece together the image. It should be emphasized, however, that the difficulties and ambiguities are deliberate, rather than the result of the viewer's lack of information with which to decode the images. Braque's comment is instructive in this regard: 'It's all the same to me whether a form represents a different thing to different people or many things at the same time', and he further claimed that some of the forms 'have no literal meaning whatsoever'.

In 1910 Picasso began to produce Cubist portraits, such as the one of Ambroise Vollard (Plate 9). Many details are illegible or lost, though the sitters remain remarkably recognizable. Only a little more attention is given to the face than to a chair or even the background, and this creates a balanced effect in which the composition is spread evenly across the canvas. Braque's work of this year shows similar characteristics, and the strong convergence of style at this time reflects the artists' attempt to forge an art that was not founded on individual personalities. Thus from about 1910 many works by Picasso and Braque are unsigned (though they were sometimes signed later) and can be confused.

The development of hermetic Cubism continued in 1911, with both artists spending several months in Céret. Most of the paintings of that year are of still lifes or single figures (see Plate 10), often with musical instruments. Typographic elements become increasingly common, sometimes deriving from newspaper names and headlines, and they are also more precisely painted. In 1912, aware that they had carried analytical Cubism as far as possible, Picasso and Braque developed several new techniques. In January Braque returned to Paris from Céret, bringing with him a painting with stencilled lettering. This was one of the techniques he had learned as a house painter when a young man and it further reduced the stamp of the artistic personality. He had also learned how to use steel combs to simulate the effect of wood grain (a technique known as *faux bois*). This first appeared in one of the works brought from Céret. After being taught the technique by Braque, soon Picasso also employed the *faux bois* effect. In addition, colour began to re-emerge in the paintings of 1912, initially used merely to pick out details.

The most important innovations of this year were the creation of paper sculpture, collage (pictures using real objects and non-artistic materials) and *papier collé*. In May 1912 Picasso made the collage *Still Life with Chair Caning* (Fig. 6) in which he added a piece of printed oilcloth to the painted still life. While giving the illusion of chair caning it represents a table-cloth (for which such material was used). Probably in early 1911 Braque had begun to make paper sculptures and continued to produce them intermittently thereafter. Though none survive, photographs and written accounts suggest that they were made from folded paper which was then either painted or drawn upon. According to Braque, it was their example that then led him to make the first *papier collé*. For this he used pieces of *faux bois* wallpaper, which he glued onto paper and over which he then drew. Later, together with Picasso, the new medium was extended to incorporate pieces of newspaper, printed labels and other paper

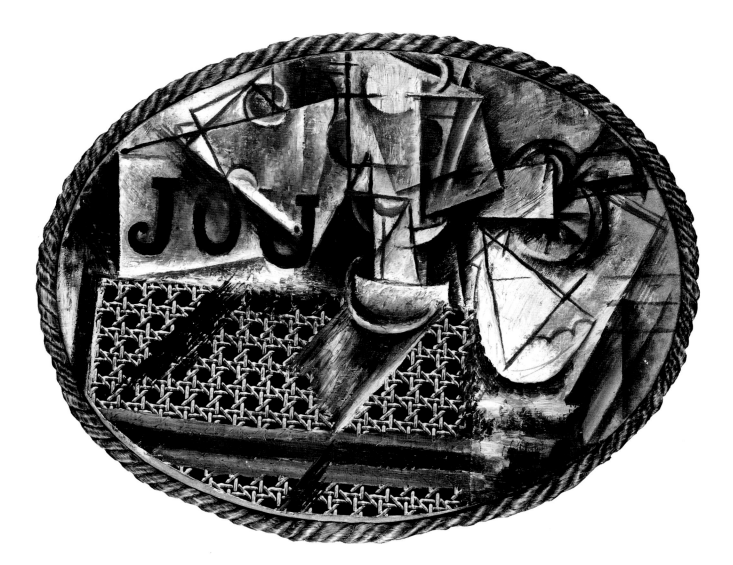

fragments. While Picasso's collage was for a while not developed further, the *papier collé* technique was rapidly taken up by both artists (see Plates 21, 23 and 31). In keeping with their temperaments, Picasso's *papiers collés* tend to employ more disparate elements whereas Braque's are more unified and balanced. Further, Braque restricted himself to an overlay of drawing alone and was less witty than Picasso, who created puns and made much of the play on reality and illusion which it allowed. It is further typical of this difference that it was Picasso who created collage. By definition this allows a greater variety of elements to be used and so encourages the production of works that lack the harmony expected of art.

Braque's early paper sculptures prompted Picasso to experiment with the technique towards the end of 1912, when he probably began his *Guitar* (Fig. 7). In this, unlike Braque's sculptures, the roles of space and solid are reversed, space being used to signify solidity and vice versa. This was to have important consequences for much later sculpture. The last of the innovations of this crowded year was the mixing of sand with paint, a process Braque developed at the same time as *papier collé*. This gave the paint a real texture and so contrasted with the deceit of *faux bois*, where what appears to be real wood has only the substance of paint.

These changes in painting techniques are in tune with the earlier concerns of Cubism. The introduction of new materials in 1912 confirmed the autonomy of the work of art by emphasizing its object

Fig. 6
PABLO PICASSO
Still Life with Chair Caning
1912. Oil, pasted oilcloth and paper on canvas with rope surround,
27 x 35 cm. Musée Picasso, Paris

15

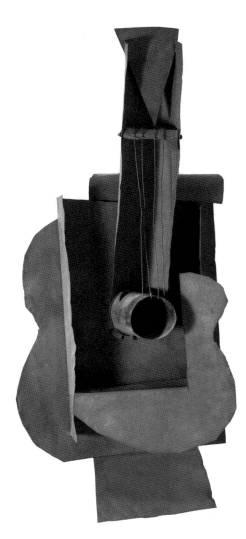

Fig. 7
PABLO PICASSO
Guitar
?1912–13. Sheet metal
and wire, h77.5 cm.
Museum of Modern Art ,
New York, NY

quality. It also added to the Cubist exploration of the possible means of representation: pieces of paper or other objects could serve the same signifying function as paint. Further, the use of tawdry materials broke the connection often made between the technical and artistic quality of a work. *Papier collé* involved none of the labour or manual skill of illusionistic painting, nor did the result have the same finesse. Paradoxically, the artistic feat might be deemed all the more impressive, however, as it required the transformation of highly unpromising ingredients into art.

The development of *papier collé* and collage heralds what is called 'synthetic' Cubism. Whereas analytical Cubism involved reducing objects to their constituent elements, in synthetic Cubism disparate, often abstract elements are brought together to create objects; in other words the object is the end result of the process rather than the beginning.

Through 1913 and 1914 the Cubism of Picasso and Braque moved further away from the sobriety of high analytical Cubism. The brighter colours and less intricate, linear structures produced more appealing pictures. Though the range of colours was extended, it was not generally used naturalistically, and in some works it was applied in dots in what is known as a Pointillist manner. Most importantly, colour provided an additional means of unifying the composition. Having made little of collage in 1912, in 1913–14 Picasso took it up again, creating a number of collages and assemblages in which a wide range of real objects were incorporated, as in the upholstery fringe of the wooden *Still Life Construction* (Plate 32) of 1914.

By 1912 another artist was making an original contribution to Montmartre Cubism: Gris. Born in Madrid, he moved to Paris in 1906 and by 1908 had taken a studio in the Bateau Lavoir building. He thus became a neighbour of Picasso and a member of the Montmartre circle. While working as an illustrator and caricaturist from 1907, in 1910 he decided to take up painting seriously. His first Cubist inspired works date from 1911 and take Cézanne as their starting point. In early 1912 he had his first exhibition at the Clovis Sagot Gallery and in March he contributed three works to the Salon des Indépendants. The same year he received a contract from Picasso and Braque's dealer Daniel Henry Kahnweiler. His reverence for Picasso was such that he addressed him as 'cher maître', which annoyed Picasso and prompted him to use the term ironically when talking to Braque. Gris's debt to Picasso was expressed in his *Portrait of Picasso* (Plate 13) of 1912, which already shows the qualities that distinguish his brand of Cubism from that of either Picasso or Braque. He used more precisely delineated forms and a clearer, more rigorous structure. Further, he quickly developed a distinctively personal way of unifying his works through the rhythmic use of form and colour across the canvas. He also rapidly assimilated the techniques of *papier collé* and collage, playing the same sort of games with them as Picasso and Braque. Gris's more intellectual, theoretical approach to art was perhaps a reflection of his training in science and engineering while in Madrid.

During the early years of Cubism, Picasso and Braque rarely exhibited their work and made little attempt to publicize it. It was thus left to others, the Salon Cubists, to champion the movement. So-called because they regularly showed at the numerous salon exhibitions in Paris, these artists briefly formed themselves into groups in order to present Cubism as a new school. At the heart of the Salon Cubist group were Metzinger and Gleizes, while others that were associated with it at some time include Léger, Delaunay, Henri le Fauconnier (1881–1946), the brothers Jacques Villon (1875–1963),

Marcel Duchamp and Raymond Duchamp-Villon (1876–1918), Francis Picabia (1879–1953), Roger de la Fresnaye (1885–1925), André Lhôte (1885–1962), Louis Marcoussis (1883–1941) and Alexander Archipenko (1887–1964). They were based in the Left Bank of Paris and the suburbs of Courbevoie and Puteaux and were thus geographically separate from Montmartre. The extent to which they were influenced by the earlier paintings of Picasso and Braque is unclear, and though the work of both artists was on display at Kahnweiler's gallery, some Salon Cubists seemed to have encountered it only relatively late. While certain stylistic similarities are evident between the art of the two groups, Salon Cubism is distinguished by its ambitious subject-matter and the large scale of its works – features that are typical of the paintings traditionally shown at the Salons. Further, it is mostly less severe both with regard to colour and spatial complexity, and there is little of the technical inventiveness or hermetic density that characterize the work of Picasso and Braque.

Another distinctive feature of the Salon Cubists was their tendency to theorize and write about their work. As neither Picasso nor Braque did much of either in public, the contemporary view of Cubism was very much influenced by these ideas. Metzinger was unique among the Salon Cubists in having an early knowledge of Montmartre Cubism and, together with Gleizes, he wrote the first book devoted solely to Cubism, *On Cubism* (1912). Of all the contemporary writings on the subject this was the most popular and incorporated many of the thoughts expressed by the numerous poets and critics associated with Cubism. The book emphasized the importance of Cézanne ('To understand Cézanne is to foresee Cubism'), the autonomy of the work of art, and the rejection of decoration ('a decorative work is the antithesis of the picture.') Nevertheless, it is full of the bombastic assertions and half-digested erudition (such as the passing reference to non-Euclidean geometry) that typified many contemporary analyses of the movement.

By 1909 various of the Salon Cubists knew each other and in 1910, at the Salon des Indépendants in March and the Salon d'Automne in October, a sense of common purpose was evident. At the Salon d'Automne the works of Metzinger, Gleizes and Le Fauconnier were hung together by chance and this fact, according to Gleizes, made these three and Léger and Delaunay aware of 'the necessity of forming a group, of frequenting each other, of exchanging ideas'. The artists thus decided to show together at the Salon des Indépendants in the spring of the following year. To do this they needed to be elected to the hanging committee and so, with their literary friends, they successfully lobbied the assembly. They chose Room 41 to hang their own works, while in the nearby Room 43 was that of other like-minded artists, including La Fresnaye and Lhôte. The publicity surrounding the exhibition was heightened by the initial hijacking of the hanging committee, and as a result the show enjoyed a *succès de scandale*. As Gleizes described it later, 'people were packing into our room, shouting, laughing, raging, protesting, giving vent to their feelings in all sorts of ways.' By writing a long defence of the show, Apollinaire came to be seen as the official spokesman of the movement (and was thus involved with both Montmartre and Salon Cubism).

After another public exhibition later in 1911 at the Galerie de l'Art Contemporain, the Salon Cubists held their next show in October 1912, called the 'Section d'Or', at the Galerie de la Boétie. This show contained over 200 works and had a more coherent artistic direction

Fig. 8
HENRI LE
FAUCONNIER
Abundance
1910–11. Oil on canvas,
318.5 x 195.5 cm.
Gemeentemuseum,
The Hague

than the previous exhibitions, attempting to show the logical development of Cubism over the preceding few years. The name of the exhibition and accompanying review – *La Section d'Or* – was apparently coined by Villon, at whose studio in Puteaux the Salon Cubists often gathered, and indicates an attempt to give the movement a more intellectual, mathematical slant (the golden section – 'Section d'Or' – is a mathematically defined classical proportion). Cubism was by this time becoming a major public phenomenon and received much critical attention. In December 1912 there was even a debate over Cubism in the Chamber of Deputies in which the Socialist deputy leader Jules-Louis Breton accused the Cubists of mounting an assault on the French heritage. He also threw in the incidental jibe that they were 'mostly foreigners'.

The unity of the Section d'Or was short-lived, its associate artists soon beginning to follow separate courses. So diffuse was Cubism by 1913 that Apollinaire felt obliged in his book, *The Cubist Painters*, to divide the movement into four rather vaguely defined categories, of which he thought the most advanced to be that more abstract tendency he labelled Orphism. According to him, the Orphists included the artists Delaunay (who did not take part in the Section d'Or exhibition), Picabia and Léger, and also the Czech painter František Kupka (1871–1957), who had been in Paris since about 1895 and was in close contact with the Puteaux Cubists from 1911–12. Apollinaire soon claimed Orphism and Cubism to be wholly distinct tendencies.

The rapid disintegration of Salon Cubism was an inevitable consequence of the diversity of styles it encompassed. The conservative pole is typified in the work of Le Fauconnier. His painting *Abundance* (Fig. 8) was thought to mark a significant progression by the other Salon Cubists and was shown in Room 41, where it received much critical attention. Formally it is unadventurous, retaining much of the structure of single-point perspective, yet it is overlaid by a geometrical treatment of the individual elements. Its subject-matter and scale are especially typical of Salon Cubism. Set against the backdrop of an idyllic landscape, the depiction of a female nude and child surrounded by the fruits of the land amounts to a traditional celebration of the fertility of nature. Gleizes' *The Bathers* (Plate 14) of 1912 is similar in scope, though it has a more radical formal structure. In style and subject-matter it shows the artist trying to deal with the modern world while retaining elements of the classical tradition. More advanced is Metzinger's *Dancer in a Café* (Plate 15), again of 1912, in which a geometrical, linear armature is used to organize the composition. Metzinger preferred, however, a more obviously contemporary subject-matter and here captures a scene from urban life.

The city assumed a central importance for many of the Salon Cubists as it seemed to exemplify the most significant tendencies of modern life, offering suitable images for the new style. Delaunay, one of the most original and independent of the Salon Cubists, focused on the Eiffel Tower in a series of works in 1910–11. As well as being the city's most prominent landmark, it was still seen as very modern, even though over 20 years old. The works in the series show the tower fragmented so that it appears precariously balanced on the verge of collapse. It is depicted in the same way in Delaunay's most ambitious treatment of the city, the huge work *The City of Paris* (Plate 16) of 1912. Prompted by a fascination with light, soon after this work he began on the road to abstraction in the 'Windows' series (see Plate 17).

The early work of Léger displays many of the concerns of Salon

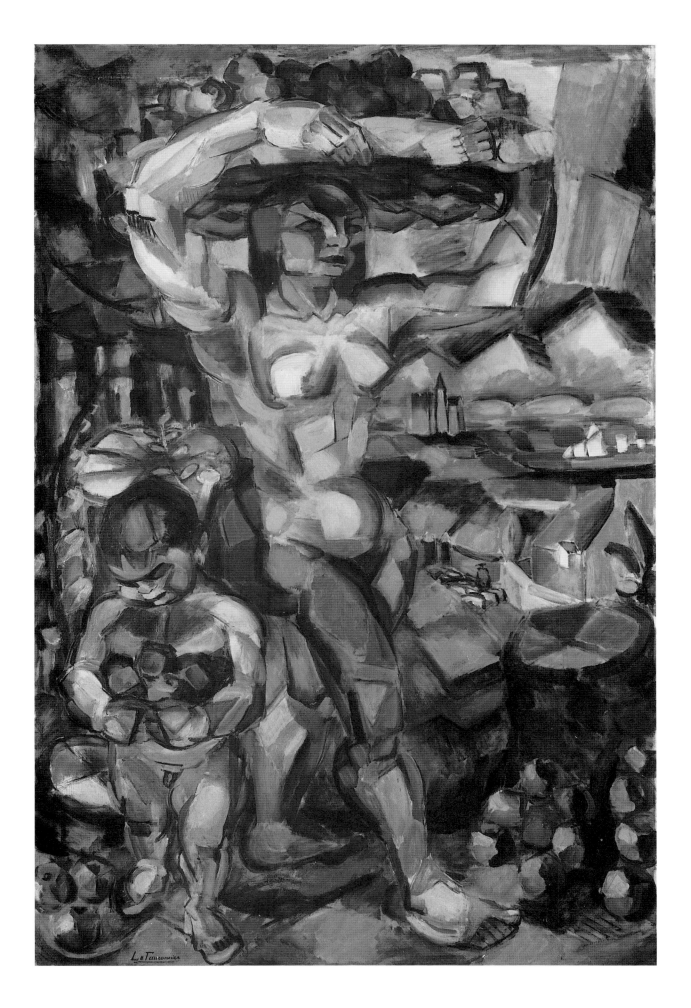

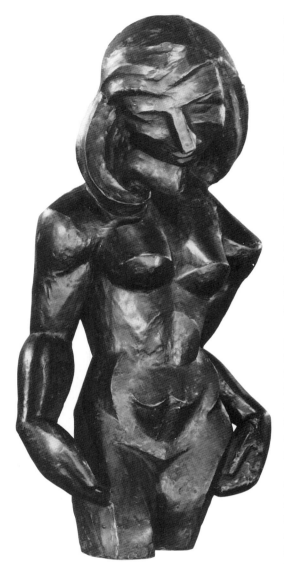

Cubism, though his approach was highly original and he soon followed an entirely independent course. Beginning with an analysis of Cézanne's work, by 1909 he had begun to adopt a sculptural style of painting, as in the elaborate *Nudes in the Forest* (Plate 5) from 1909–11. This shows him wrestling with new formal concerns, while treating an epic subject that is typical of Salon Cubism of this date. However, his exploration of form soon took a more radical turn. From these solid, block-like early compositions he moved towards a much flatter, spatially complex Cubist idiom in which he mixed abstract and figurative elements, the former being used to cement the composition together, as in *The Wedding* (Plate 11) of 1911–12 or the *Woman in Blue* (Fig. 19) of 1912. This latter has affinities with the hermetic works of Picasso and Braque, though it is distinguished by the variety of colours and forms which lend the work a greater dynamism. His interest in the pure dynamic possibilities of painting resulted in a series of abstract works called 'Contrasts of Form', executed in 1913–14. In these, geometrical elements executed in primary colours jostle across the surface of the canvas. Léger applied the same style to a number of figurative works.

Like the Montmartre Cubists, the Salon Cubists also explored the possibilities of sculpture. Again a spectrum of styles emerged: among the first tentative steps in the medium is La Fresnaye's *Italian Girl* (Fig. 9). More important was the Russian Archipenko who had worked in Paris from 1908 and also exhibited with the Section d'Or. Starting from an analysis of Picasso and Braque's work, he extended their use of open space in his own constructions, in which he began to use a disparate range of materials – some painted – such as wood, tin, glass and cloth, as in *Médrano II (Dancer)* (Plate 27) of 1913.

Soon after its proliferation in Paris, Cubism was absorbed by a whole range of foreign artists. In February 1909 the Italian poet Filippo Marinetti published the bombastic *Futurist Manifesto*, which claimed a roaring car to be more beautiful than the *Victory of Samothrace* (a famous Hellenistic sculpture in the Louvre, Paris), glorified war as the 'sole hygiene of the world' and announced the death of Time and Space. A group of artists soon gathered around Marinetti: Umberto Boccioni (1882–1916), Gino Severini (1883–1966), Carlo Carrà (1881–1966), Giacomo Balla (1871–1958) and Luigi Russolo (1885–1947). In late 1911 Severini, who had met Picasso and Apollinaire, took the Futurists to Paris, so bringing them into contact with Cubism. Adapted to their own purposes, it allowed them to create dynamic images that were emphatically focused on the modern world, with depictions of trains, cars and crowds, and of speed and energy itself (see Plate 19). Boccioni's *States of Mind: The Farewells* (Fig. 10) of 1911, centred on the image of a train, shows its first effects. The Futurists were both more organized and united than the Cubists and, having appropriated their style, soon attacked them for being too preoccupied with painting itself and insufficiently concerned with the modern world.

In Russia there was a strong desire to create a distinctively national style, yet Cubism and Futurism both influenced several artists in the 1910s, for example Natalia Gontcharova (1881–1962) as in *Electric Lamps* (Plate 20) and Mikhail Larionov (1881–1964). In 1911–12 the latter invented Rayonism, an attempt to depict the rays of light reflected from objects using spiky, splintered forms. Kasimir Malevich (1878–1935) also drew on Cubism and Futurism, especially in 1912–13. In pictures such as *The Knife Grinder* (Fig. 11) of 1913 he adopted the cinematic, sequential imagery favoured by the Futurists so as to suggest movement, while in others he used the abstract planes

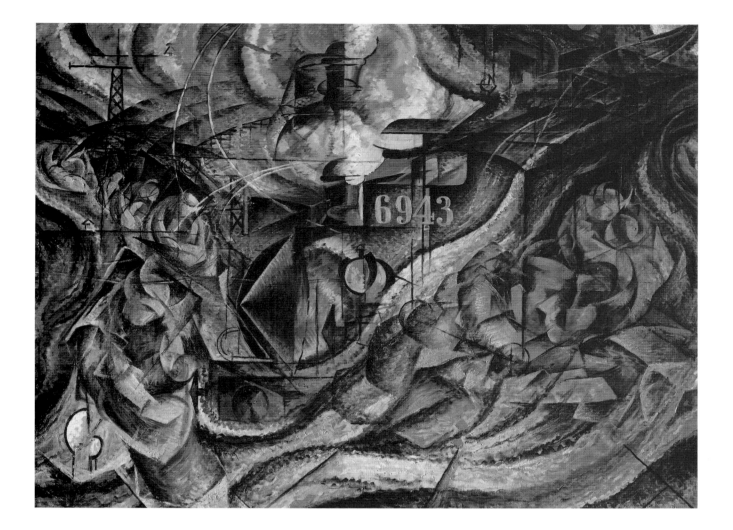

of synthetic Cubism (see Fig. 24). Other painters such as Liubov Popova (1889–1924) and Nadezhda Udalsova (1886–1961) adhered to a more orthodox form of Cubism.

Though opposed to the calm discipline of Cubism, certain of the Expressionists in Germany, nevertheless, found in it elements of interest. For example, the American-born Lyonel Feininger (1871–1956) used a geometric, crystalline style in his ghostly scenes of architecture and landscapes (see Plate 30). A similarly personal Cubist inflection is evident in the works of Franz Marc (1880–1916) whose zealously spiritual beliefs were expressed in brightly coloured pictures of animals (see Plate 34). Due to its geographical position and the various exhibitions organized there, Cubism also emerged very quickly – from 1910 – in Czechoslovakia. Though blended with the earlier influence of Expressionism, a more orthodox form of Cubism was created than in Germany. Works such as *Tray with Bunch of Grapes* (Plate 36) by Emil Filla (1882–1953) are close to Picasso and Braque's work of that time. The sculpture of Otto Gutfreund (1889–1927) extends two dimensional analytical Cubism successfully into the round, as shown by his *Man's Head* (Fig. 29).

England had a relatively early experience of both Cubism and Futurism, and the first British response to these movements was Vorticism, founded by Wyndham Lewis (1884–1957) in 1914. Though derivative of both, the Vorticists tried to distinguish themselves from either and in 1915 Lewis attacked the 'tasteful passivity of Picasso' and the 'fuss and hysterics of Futurism'. Coined

Fig. 10
UMBERTO BOCCIONI
States of Mind: The
Farewells
1911. Oil on canvas,
70.5 x 95.5 cm.
Museum of Modern Art,
New York, NY

Fig. 11
KASIMIR MALEVICH
The Knife Grinder
1913. Oil on canvas,
79.5 x 79.5 cm.
Yale University Art
Gallery, New Haven, CT

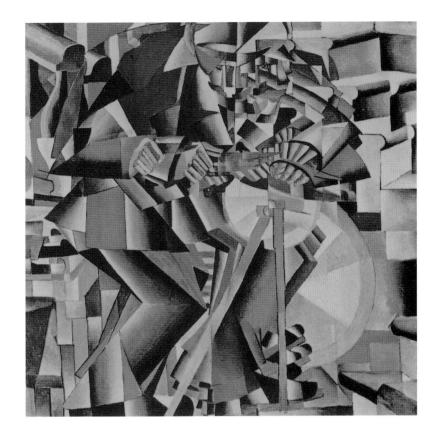

by the American poet Ezra Pound, the label 'Vorticism' was intended to describe the vortex of energy and dynamism in their works (see Plate 37 and Figs. 30 and 31). The 11 signatories of the manifesto that appeared in the first issue of their bombastic journal *Blast* included the sculptor Henri Gaudier-Brzeska (1891–1915) and the painters Edward Wadsworth (1889–1949) and William Roberts (1895–1980) as well as Lewis. Others associated with the short-lived movement were the painters David Bomberg (1890–1957), Christopher Nevinson (1889–1946) and the sculptor Jacob Epstein (1880–1959).

In America, the famous Armory Show of 1913, which travelled from New York to Chicago and Boston, brought the American public face to face with progressive European art. By this time its effects were already evident in the works of such artists as Max Weber (1881–1961), John Marin (1870–1953) and Joseph Stella (1880–1946). All of them had been in Europe for some years and employed the geometric spatial devices of Cubism in some of their works from the mid-1910s (see Plate 38, Fig. 32). In Paris itself a group of Americans led by Morgan Russell (1886–1953) and Stanton Macdonald-Wright (1890–1973) developed a form of abstraction called Synchromism, which was derived from the colourful Orphist works of Delaunay. Others such as Stuart Davis (1892–1964) were prompted by the Armory Show to take up Cubism (see Plate 45).

The outbreak of World War I in 1914 drastically affected the development of Cubism in France. Many Cubists were mobilized: Léger, Braque, Metzinger, Gleizes, La Fresnaye, Kupka, Villon and others. Those who were left were either foreigners from neutral countries, such as Picasso, Gris and the sculptor Jacques Lipchitz (1891–1973) or medically unfit like the sculptor Henri Laurens (1885–1954). Of those mobilized, most had to give up art for war: Léger and La Fresnaye were exceptions who managed to continue working spasmodically. By 1914 faultlines had in any case become

apparent in both Montmartre and Salon Cubism and the outbreak of war merely gave physical expression to this, as the group was scattered. Though far from extinct, from this time onwards Cubism nevertheless lacked the innovative intensity of the pre-war years.

In Paris, life was made harsh both through material privation and the public hostility towards non-combatants. During and after the war there was a vehemently conservative strain in French culture termed the 'recall to order', which was fuelled by a nationalist desire to redefine and consolidate the Latin, classical tradition of French art. Picasso's art consequently evolved schizophrenically: he returned to naturalism in some works (even employing a heavy Neo-classical style in the 1920s), while also pursuing a parallel Cubist course. He continued to make greater use of colour, frequently in a Pointillist manner, and in some essentially Cubist works he incorporated naturalistic details amidst the flattened, abstract planes. His first important Cubist work after 1914 is *Harlequin* (Fig. 12) of 1915, which shows a renewed interest in his pre-Cubist subject-matter, but has a severely simplified composition of few elements. Subsequent paintings such as *Three Musicians* (Plate 43) of 1921 have the clear, precise forms typical of much post-war Cubism, sometimes labelled 'crystal' Cubism.

Gris was one of the few other active Cubists during the war, at which time his art fully matured. Like Picasso, he experimented with naturalism again, but concentrated on elaborate Cubist works in which colour plays an important role as a means of suggesting space as well as aiding legibility, as seen in the striking *Still Life before an Open Window: Place Ravignan* (Plate 35) of 1915. Clean outlines and rich colours underpin his attractive, lucid form of Cubism, which perfectly exemplifies the general features of crystal Cubism. In contrast to the work of other Cubists, that of Gris shows a unique consistency of development that continued until his premature death in 1927.

Following demobilization in 1916, Braque took up painting again in 1916–17. The separation of war merely confirmed the artistic divergence between himself and Picasso that was beginning to show by 1914, and on his return, he was no longer in close contact with his old friend. Taking up where he left off, he executed synthetic Cubist treatments of still lifes and other subjects, usually restricting himself to a palette of rich earth colours. The 'recall to order' led him, too, to flirt with Neo-classicism, but generally he continued to consolidate the lessons of Cubism for the rest of his life, evolving a more simplified, decorative manner, as in *Fruit on a Table-cloth with a Fruit Dish* (Plate 46).

For Léger, the war itself was the subject of some works; he found the Cubist style well suited to the dehumanized, mechanistic world of the ordinary soldier, as in *The Card Players* (Plate 40). The experience of war and his pragmatic temperament resulted in a more legible style. By the early 1920s the geometric fragmentation of his Cubist pictures had given way to the smooth, solid style that characterized his work thereafter and that was used in monumental canvases of ordinary people at work and leisure.

Cubist sculpture made great progress after 1914, through the work of Laurens, Lipchitz, Archipenko and others, as well as Picasso. Though he had come to Paris in 1909, the Lithuanian sculptor Lipchitz did not experiment with Cubism until 1913–14 and from 1915 he was a close friend of Gris. He soon developed a style using clear, abstract solids to construct sculptures of figures and heads. Though mostly working in bronze and stone, in 1915 he produced a series of wooden or bronze 'detachable figures' in which he applied

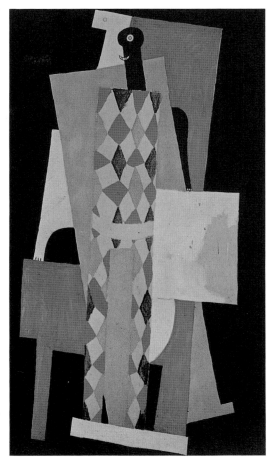

Fig. 12
PABLO PICASSO
Harlequin
1915. Oil on canvas,
183 x 105 cm.
Museum of Modern Art,
New York, NY

the synthetist technique of building up the sculptures from separate, abstract elements, as in *Detachable Figure: Dancer* (Fig. 13), a work that resembles Picasso's *Harlequin* (Fig. 12). The Frenchman Laurens had been a close friend of Braque before the war and came to know Picasso in 1915, the year in which he produced his first Cubist works. Having experimented with constructions, he turned predominantly to the more permanent media of stone and terracotta, sometimes painted, and his elegant heads and still lifes have a great economy of form (see Plate 42). Following the innovations of his pre-war sculpture, Archipenko continued to develop the Cubist construction. He developed a hybrid medium he called 'sculpto-painting', in which he extended the combination of relief sculpture and painting seen in the earlier *Médrano II (Dancer)* (Plate 27).

In 1919 the poet and friend of Léger, Blaise Cendrars, wrote:

> To refuse to recognize the importance of the Cubist movement would be fatuous, just as to laugh at it was idiotic. But it is quite as idiotic and fatuous to try to stop at a doctrine which today is dated, and to refuse to recognize that Cubism no longer offers enough novelty and surprise to provide nourishment for a new generation...The 'home from the Front generation' has its mind aroused by other problems, and its researches point in a new direction.

Despite such attempts to sweep it aside, Cubism remained a powerful force in France until the mid-1920s. Cubist exhibitions continued to be held: Gleizes even revived the Section d'Or exhibition in 1920 and 1925. However, other movements were struggling to replace it. The first of these was Purism, which was created by Amédée Ozenfant (1886–1966) and Charles Édouard Jeanneret (1887–1965), better known as the architect Le Corbusier. In place of the eclecticism of Cubism, the Purists wished to substitute a more rigorous, scientific form of painting and produced rather sterile still lifes that are formally indebted to Cubism (see Plate 47). Contemporary with Purism was Dada, which had begun in Zurich in 1915 but became established in Paris only with the arrival of the poet Tristan Tzara in January 1920. It gathered together such proto-Surrealists as André Breton (1896–1966) and Louis Aragon (1897–1982) as well as Picabia, Duchamp and, briefly, Gleizes. Dada was anarchic and iconoclastic, a frenzied reaction to the slaughter of war, and, though its prime targets were social hypocrisy and complacency, it also attacked the Cubists for their part in the pre-war culture. The Cubists were seen as self-obsessed and socially detached, Picabia claiming in 1920 that they had 'cubed' everything – they had 'cubed shit and the profiles of young girls' and that it only remained necessary for them to 'cube money'.

When Dada fizzled out, many of its participants took up Surrealism under the leadership of Breton. Paradoxically, though focused on the unconscious, Surrealism rapidly acquired a political mantle, dedicating itself to the Communist cause. This attempt to bridge the gap between artistic and social engagement was a keynote of the inter-war years and highlights what was thought to be the failure of Cubism. Despite its fall from grace it did, however, influence the work of Surrealists such as André Masson (1896–1987) and Joan Miró (1893–1983). Elsewhere, it was taken up by new artists such as the Englishman Ben Nicholson (1894–1982) in works such as *Trendrine 2* (Plate 48), further evidence of its continued ability to inspire.

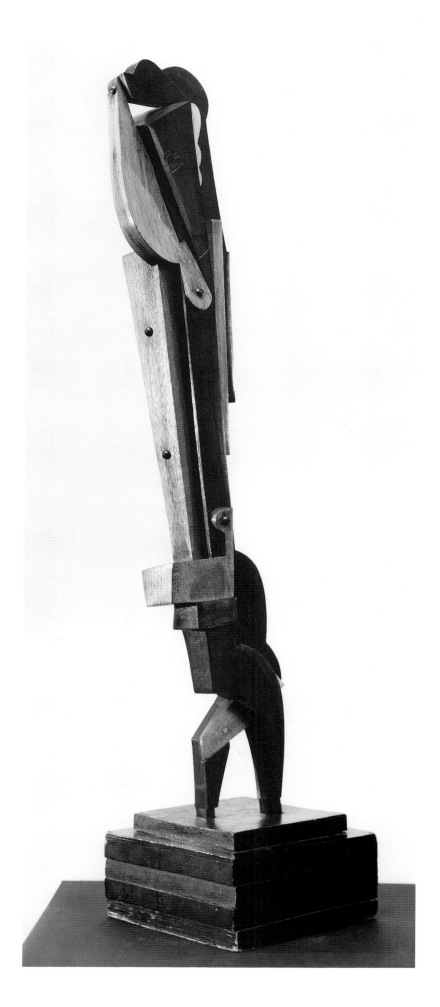

Fig. 13
JACQUES LIPCHITZ
Detachable Figure:
Dancer
1915. Wood, h85 cm.
Private collection

Select Bibliography

Robert Rosenblum, *Cubism and Twentieth-century Art*, New York and London, 1960

Edward Fry, *Cubism*, London, 1966

Paul Waldo Schwarz, *The Cubists*, London, 1971

Nicholas Wadley, *Cubism*, London, 1972

Christopher Green, *Léger and the Avant-garde*, London, 1976

Pierre Daix and Joan Rosselet, *Picasso: The Cubist Years, 1907–1916*, London, 1979

Virginia Spate, *Orphism*, Oxford, 1979

Nicole Worms de Romilly and Jean Laude, *Braque: Cubism, 1907–14*, Paris, 1982

Mark Rosenthal, *Juan Gris*, New York, 1983

Mark Roskill, *The Interpretation of Cubism*, Philadelphia, 1986

Christopher Green, *Cubism and its Enemies: Modern Movements and Reaction in French Art, 1916–28* , New Haven and London, 1987

John Golding, *Cubism: A History and Analysis, 1907–1914*, 3rd edition, London, 1988

Alexander von Vegesack (ed.), *Czech Cubism: Architecture, Furniture and Decorative Arts*, London, 1992

Pierre Daix, *Picasso: Life and Art*, London, 1993

Douglas Cooper, *The Cubist Epoch*, 2nd edition, London, 1994

Exhibition Catalogues

Albert Gleizes, Solomon R Guggenheim Museum, New York, 1964

Pablo Picasso: A Retrospective, Museum of Modern Art, New York, 1980

Braque: The Papiers Collés, National Gallery of Art, Washington DC, 1982–3

Jean Metzinger in Retrospect, University of Iowa Museum of Art, Iowa City, 1985

Georges Braque, Solomon R Guggenheim Museum, New York, 1988

Picasso and Braque: Pioneering Cubism, Museum of Modern Art, New York, 1988

Juan Gris, Whitechapel Art Gallery, London, 1992

Picasso: Painter-Sculptor, Tate Gallery, London, 1994

The Phaidon Colour Library series includes the following titles on artists associated with Cubism:

Catherine Dean, *Cézanne*, London, 1991

Roland Penrose, *Picasso*, 2nd edition, London, 1991

List of Illustrations

Colour Plates

1 PAUL CÉZANNE
Still Life with Plaster Cupid
*c*1895. Oil on paper on wood, 70 x 57 cm.
Courtauld Institute Galleries, London

2 PAUL CÉZANNE
Mont Sainte-Victoire
*c*1902–6. Oil on canvas, 65 x 81 cm.
Stiftung Sammlung E G Bührle, Zurich

3 PABLO PICASSO
Les Demoiselles d'Avignon
1907. Oil on canvas, 244 x 234 cm.
Museum of Modern Art, New York, NY

4 GEORGES BRAQUE
Harbour in Normandy
1909. Oil on canvas, 81 x 81 cm.
Art Institute, Chicago, IL

5 FERNAND LÉGER
Nudes in the Forest
1909–11. Oil on canvas, 120 x 170 cm.
Rijksmuseum Kröller-Müller, Otterlo

6 PABLO PICASSO
Seated Nude
1910. Oil on canvas, 92 x 73 cm.
Tate Gallery, London

7 GEORGES BRAQUE
Violin and Pitcher
1910. Oil on canvas, 117 x 73 cm.
Kunstmuseum, Basel

8 GEORGES BRAQUE
Woman with a Mandolin
1910. Oil on canvas, 92 x 73 cm.
Bayerische Staatsgemäldesammlungen, Munich

9 PABLO PICASSO
Portrait of Ambroise Vollard
1910. Oil on canvas, 92 x 65 cm.
Pushkin Museum, Moscow

10 GEORGES BRAQUE
Woman Reading
1911. Oil on canvas, 130 x 81 cm.
Ernst Beyeler Collection, Basel

11 FERNAND LÉGER
The Wedding
1911–12. Oil on canvas, 257 x 206 cm.
Musée National d'Art Moderne, Centre Georges
Pompidou, Paris

12 MARC CHAGALL
Homage to Apollinaire
1911–13. Oil and powdered gold and silver on
canvas, 200 x 189.5 cm.
Stedelijk Van Abbemuseum, Eindhoven

13 JUAN GRIS
Portrait of Picasso
1912. Oil on canvas, 93 x 74 cm.
Art Institute, Chicago, IL

14 ALBERT GLEIZES
The Bathers
1912. Oil on canvas, 105 x 170 cm.
Musée d'Art Moderne de la Ville de Paris, Paris

15 JEAN METZINGER
Dancer in a Café
1912. Oil on canvas, 146 x 114 cm.
Albright Knox Art Gallery, Buffalo, NY

16 ROBERT DELAUNAY
The City of Paris
1912. Oil on canvas, 265.5 x 402.5 cm.
Musée National d'Art Moderne, Centre Georges
Pompidou, Paris

17 ROBERT DELAUNAY
Windows Open Simultaneously:
First Part, Third Motif
1912. Oil on canvas, 46 x 37.5 cm.
Tate Gallery, London

18 MARCEL DUCHAMP
Nude Descending a Staircase II
1912. Oil on canvas, 146 x 89 cm.
Museum of Art, Philadelphia, PA

19 GINO SEVERINI
Dynamic Hieroglyph of the Bal Tabarin
1912. Oil on canvas with sequins, 160 x 155 cm.
Museum of Modern Art, New York, NY

20 NATALIA GONTCHAROVA
Electric Lamps
1912. Oil on canvas, 105 x 81 cm.
Musée National d'Art Moderne, Centre Georges
Pompidou, Paris

21 PABLO PICASSO
Bowl with Fruit, Violin and Wineglass
1912–13. Pasted paper, watercolour, chalk, oil and
charcoal on cardboard, 65 x 50.5 cm.
Museum of Art, Philadelphia, PA

22 GEORGES BRAQUE
Fruit Dish, Ace of Clubs
1913. Oil, gouache and charcoal on canvas,
81 x 60 cm.
Musée National d'Art Moderne, Centre Georges
Pompidou, Paris

23 PABLO PICASSO
Bottle of Vieux Marc, Glass, Guitar and
Newspaper
1913. Pasted paper and ink on paper, 46.5 x 62.5 cm.
Tate Gallery, London

24 PABLO PICASSO
Guitar, Gas Jet and Bottle
1913. Oil, sand and charcoal on canvas, 68.5 x 53.5 cm.
Scottish National Gallery of Modern Art,
Edinburgh

25 JUAN GRIS
Pears and Grapes on a Table
1913. Oil on canvas, 54.5 x 73 cm. Private collection

26 ROBERT DELAUNAY
Sun, Tower, Aeroplane: Simultaneous
1913. Oil on canvas, 132 x 131 cm.
Albright Knox Art Gallery, Buffalo, NY

27 ALEXANDER ARCHIPENKO
Médrano II (Dancer)
1913. Painted tin, wood, glass and oilcloth, h127 cm.
Solomon R Guggenheim Museum, New York, NY

28 FRANCIS PICABIA
Udnie (Young American Girl: Dance)
1913. Oil on canvas, 300 x 300 cm.
Musée National d'Art Moderne, Centre Georges
Pompidou, Paris

29 PIET MONDRIAN
Composition in Grey Blue
1913. Oil on canvas, 79.5 x 63.5 cm.
Fundación Colección Thyssen-Bornemisza, Madrid

30 LYONEL FEININGER
The Bridge I
1913. Oil on canvas, 80 x 100 cm.
George Washington University Gallery of Art,
St Louis, MO

31 GEORGES BRAQUE
Violin and Pipe: *Le Quotidien*
1913–14. Chalk, charcoal and pasted paper on
paper, 74 x 106 cm.
Musée National d'Art Moderne, Centre Georges
Pompidou, Paris

32 PABLO PICASSO
Still Life Construction
1914. Painted wood with upholstery fringe,
h25.5 cm. Tate Gallery, London

33 PABLO PICASSO
Green Still Life
1914. Oil on canvas, 60 x 79.5 cm.
Museum of Modern Art, New York, NY

34 FRANZ MARC
Deer in a Forest II
1913–14. Oil on canvas, 110.5 x 100.5 cm.
Staatliche Kunsthalle, Karlsruhe

35 JUAN GRIS
Still Life before an Open Window:
Place Ravignan
1915. Oil on canvas, 116 x 89 cm.
Museum of Art , Philadelphia, PA

36 EMIL FILLA
Tray with Bunch of Grapes
1915. Watercolour and oil with sand on plywood,
39.5 x 30 cm. Národní Galerie, Prague

37 EDWARD WADSWORTH
Abstract Composition
1915. Ink and gouache on paper, 42 x 34.5 cm.
Tate Gallery, London

38 MAX WEBER
Chinese Restaurant
1915. Oil on canvas, 101.5 x 122 cm.
Whitney Museum of Art, New York, NY

39 JUAN GRIS
Portrait of Josette Gris
1916. Oil on canvas, 116 x 73 cm.
Museo Nacional del Prado, Madrid

40 FERNAND LÉGER
The Card Players
1917. Oil on canvas, 129 x 193 cm.
Rijksmuseum Kröller-Müller, Otterlo

41 FERNAND LÉGER
The City
1919. Oil on canvas, 236.5 x 305.5 cm.
Museum of Art, Philadelphia, PA

42 HENRI LAURENS
Head of a Boxer
1920. Stone, h31 cm. Galerie Louise Leiris, Paris

43 PABLO PICASSO
Three Musicians
1921. Oil on canvas, 203 x 189 cm.
Museum of Art , Philadelphia, PA

44 JUAN GRIS
The View across the Bay
1921. Oil on canvas, 65 x 100 cm.
Musée National d'Art Moderne, Centre Georges
Pompidou, Paris

45 STUART DAVIS
Lucky Strike
1921. Oil on canvas, 84.5 x 45.5 cm.
Museum of Modern Art, New York, NY

46 GEORGES BRAQUE
Fruit on a Table-cloth with a Fruit Dish
1925. Oil on canvas, 130.5 x 75 cm.
Musée National d'Art Moderne, Centre Georges
Pompidou, Paris

47 AMÉDÉE OZENFANT
Still Life with Jug
c1925. Oil on canvas, 50 x 61.5 cm.
Private collection

48 BEN NICHOLSON
Trendrine 2
1947. Oil on canvas, 38 x 37 cm.
Phillips Collection, Washington DC

Text Illustrations

1 Pablo Picasso
 1904. Photograph

2 GEORGES BRAQUE
 Large Nude
 1907–8. Oil on canvas, 140 x 100 cm.
 Private collection

3 GEORGES BRAQUE
 Road at L'Estaque
 1908. Oil on canvas, 60 x 50 cm.
 Museum of Modern Art, New York, NY

4 PABLO PICASSO
 Le Bock (Glass of Beer)
 1909. Oil on canvas, 81 x 65.5 cm.
 Musée d'Art Moderne, Villeneuve d'Ascq

5 PABLO PICASSO
 Head of a Woman (Fernande)
 1909. Bronze, h41 cm. Art Center, Fort Worth, TX

6 PABLO PICASSO
 Still Life with Chair Caning
 1912. Oil, pasted oilcloth and paper on canvas with
 rope surround, 27 x 35 cm. Musée Picasso, Paris

7 PABLO PICASSO
 Guitar
 ?1912–13. Sheet metal and wire, h77.5 cm.
 Museum of Modern Art , New York, NY

8 HENRI LE FAUCONNIER
 Abundance
 1910–11. Oil on canvas, 318.5 x 195.5 cm.
 Gemeentemuseum, The Hague

9 ROGER DE LA FRESNAYE
 Italian Girl
 1911. Bronze, h61 cm. Private collection

10 UMBERTO BOCCIONI
 States of Mind: The Farewells
 1911. Oil on canvas, 70.5 x 95.5 cm.
 Museum of Modern Art, New York, NY

11 KASIMIR MALEVICH
 The Knife Grinder
 1913. Oil on canvas, 79.5 x 79.5 cm.
 Yale University Art Gallery, New Haven, CT

12 PABLO PICASSO
 Harlequin
 1915. Oil on canvas, 183 x 105 cm.
 Museum of Modern Art, New York, NY

13 JACQUES LIPCHITZ
 Detachable Figure: Dancer
 1915. Wood, h85 cm. Private collection

Comparative Figures

14 PAUL CÉZANNE
Basket with Apples, Bottle, Biscuits
and Fruit
1890–4. Oil on canvas, 65.5 x 81.5 cm.
Art Institute, Chicago, IL

15 PABLO PICASSO
Nude Woman Seated
1908. Oil on canvas, 150 x 99 cm.
State Hermitage Museum, St Petersburg

16 GEORGES BRAQUE
The Castle at La Roche-Guyon
1909. Oil on canvas, 81 x 60 cm. Private collection

17 FERNAND LÉGER
Woman Sewing
1909. Oil on canvas, 73 x 54.5 cm. Private collection

18 GEORGES BRAQUE
Woman with a Guitar
1913. Oil and charcoal on canvas, 130 x 73 cm.
Musée National d'Art Moderne, Centre Georges
Pompidou, Paris

19 FERNAND LÉGER
Woman in Blue
1912. Oil on canvas, 193 x 132 cm.
Kunstmuseum, Basel

20 JUAN GRIS
The Eggs
1911. Oil on canvas, 57 x 38 cm.
Staatsgalerie, Stuttgart

21 ALBERT GLEIZES
Portrait of Stravinsky
1914. Oil on canvas, 129.5 x 114.3 cm.
Private collection

22 RAYMOND DUCHAMP-VILLON
Large Horse
1914. Bronze, h149.9 cm.
Museum of Fine Arts, Houston, TX

23 GINO SEVERINI
Train in the City
1913. Charcoal on paper, 49.8 x 64.8 cm.
Metropolitan Museum of Art, New York, NY

24 KASIMIR MALEVICH
An Englishman in Moscow
1914. Oil on canvas, 88 x 57 cm.
Stedelijk Museum, Amsterdam

25 PIET MONDRIAN
Still Life with Gingerpot II
1912. Oil on canvas, 91.5 x 120 cm.
Gemeentemuseum, The Hague

26 LYONEL FEININGER
Yellow Street
1917. Oil on canvas, 86 x 95.5 cm.
Museum of Fine Arts, Montreal

27 PABLO PICASSO
Violin and Bottle on a Table
1915. Wood, string, nails and charcoal, h42 cm.
Musée Picasso, Paris

28 GEORGES BRAQUE
Bottle of Rum
1914. Oil on canvas, 46 x 55 cm. Private collection

29 OTTO GUTFREUND
Man's Head
1913. Bronze, h60 cm. Národní Galerie, Prague

30 WYNDHAM LEWIS
The Crowd
1914–15. Oil on canvas, 200.5 x 153.5 cm.
Tate Gallery, London

31 DAVID BOMBERG
Ju-Jitsu
c1913. Oil on canvas, 62 x 62 cm.
Tate Gallery, London

32 JOHN MARIN
Woolworth Building
1912. Watercolour on paper, 48 x 38.5 cm.
National Gallery of Art, Washington DC

33 JUAN GRIS
Harlequin with Guitar
1917. Oil on canvas, 100 x 65 cm. Private collection

34 HENRI LAURENS
The Clown
1915. Painted wood, h60 cm.
Moderna Museet, Stockholm

35 PABLO PICASSO
Manager in Evening Dress
1917. Photograph of a costume from the ballet
Parade

36 GEORGES BRAQUE
Still Life on a Pedestal Table
1929. Oil on canvas, 146 x 114 cm.
Phillips Collection, Washington DC

PAUL CEZANNE (1839–1906)
Still Life with Plaster Cupid

*c*1895. Oil on paper on wood, 70 x 57 cm. Courtauld Institute Galleries, London

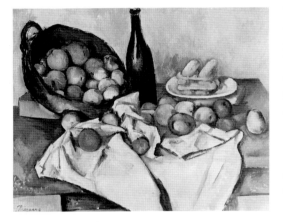

Fig. 14
PAUL CÉZANNE
Basket with Apples,
Bottle, Biscuits and
Fruit
1890–4. Oil on canvas,
65.5 x 81.5 cm. Art
Institute, Chicago, IL

This is one of Cézanne's most complex still lifes and is dominated by the plaster cast of a Baroque sculpture of Cupid in the Louvre, formerly attributed to Pierre Puget (1620–94), now to François Duquesnoy (1594–1643). Around its base on a table are apples and onions, with some of the apples in a fruit bowl that stands on a draped cloth. At the top right, in the background, is a picture of a cast of the *Flayed Man*, a sculpture attributed to Michelangelo, while on the left-hand side is Cézanne's own picture *Still Life with Peppermint Bottle* of 1890–4 (National Gallery of Art, Washington DC). In the background behind the Cupid is another canvas resting against the wall. A conceptual play is thus set up in the picture; there are the 'real' apples and onions (in fact also painted) beside those in the canvas within the painting, and a cast of a sculpture together with a painting of cast of a sculpture.

The compositional structure is also interesting; the draped cloth on the table blends with that in the picture adjacent to it, while the shoots of the onion, sharply cut off by the bottom of the *Still Life with Peppermint Bottle*, merge with the table leg depicted within it. The sculpture, only 45 centimetres high in reality, is shown oversize, and in the same way, the painting of *Still Life with Peppermint Bottle* is disproportionately large for its relative position in the work. Even more peculiar is the solitary apple in the background, which is the same size as those in the foreground and seems to hover in unresolved space, the floor on which it rests seemingly pulled upwards. This connection between foreground and background is enhanced by the thematic relation between the Cupid and the image of the *Flayed Man*. Such devices are also found in other of Cézanne's still lifes, for example *Basket with Apples, Bottle, Biscuits and Fruit* (Fig. 14) in which the biscuits on the right have been titled forward, the top two seeming to float. In addition, the edges of the table on either side of the basket do not seem to connect. The Cubists freely used and developed this sort of manipulation of the pictorial space and perspective.

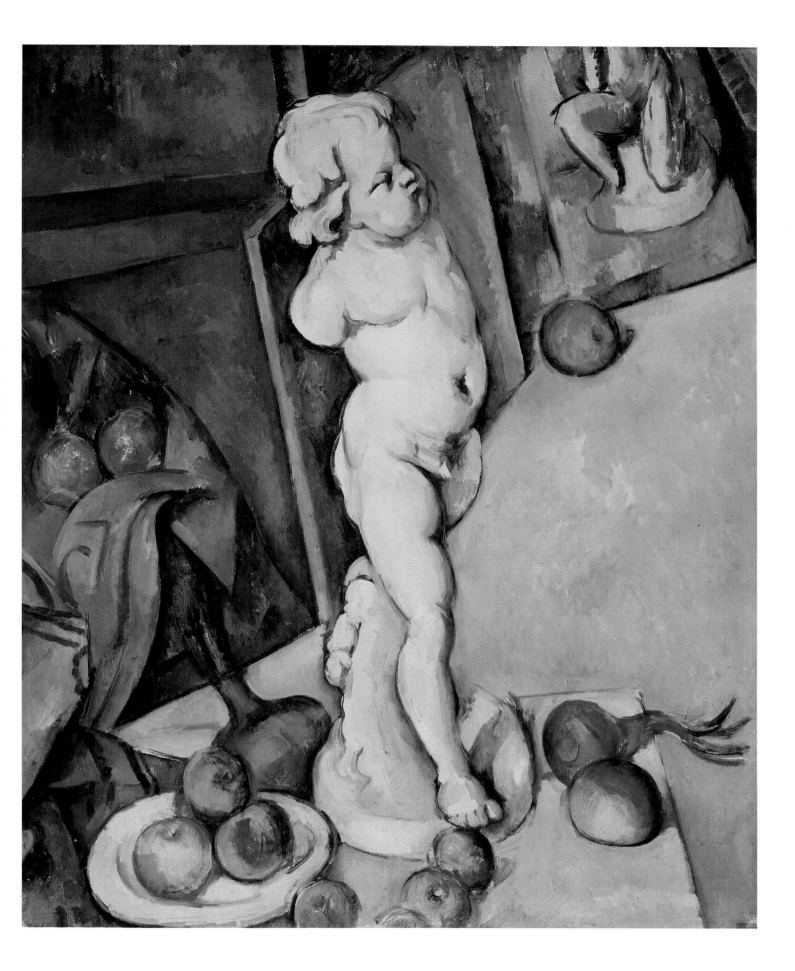

2

PAUL CÉZANNE (1839–1906)
Mont Sainte-Victoire

*c*1902–6. Oil on canvas, 65 x 81 cm. Stiftung Sammlung E G Bührle, Zurich

As the main landscape feature near his native Aix-en-Provence, the Mont Sainte-Victoire appears in many of Cézanne's canvases, but it is in the series of late works that it is given the most concentrated attention. In 1901 the artist bought a plot of land on the hillside towards Les Lauves, near Aix-en-Provence, and had a studio built there. From this vantage point he had a magnificent view of Mont Sainte-Victoire and in each of these late landscapes it appears with the same distinctive profile as seen here. The artist's repeated depictions of the same subject reflect his belief in the importance of studying nature.

According to Cézanne, apart from nature, the other foundation of art was structure, and from the 1880s he applied his paint in careful, parallel strokes so as to infuse his works with a strong sense of order. Increasingly, after about 1895 these dabs of colour became so obtrusive in the landscapes as to give the picture surface an almost abstract quality. The painting shown here consequently has the appearance of a mosaic, but, in contrast to Pointillism (a technique in which dots of colour are juxtaposed so that they blend into one when viewed from a distance), the discrete touches of colour refuse to merge even from a distance. The rich colours – violets, blues, greens, yellows and oranges – are occasionally punctuated by patches of bare white canvas, evidence of this meticulous, constructive technique, yet also reminders that the picture is an object. The distribution of the facets across the canvas, almost independent of the subject, tends to flatten the space and is also used to bridge the gaps between distant features, as is apparent in the plain in the foreground. Though, unlike the Cubists, Cézanne remained ultimately tied to observation, these pictorial devices proved a very fruitful source of investigation for later artists.

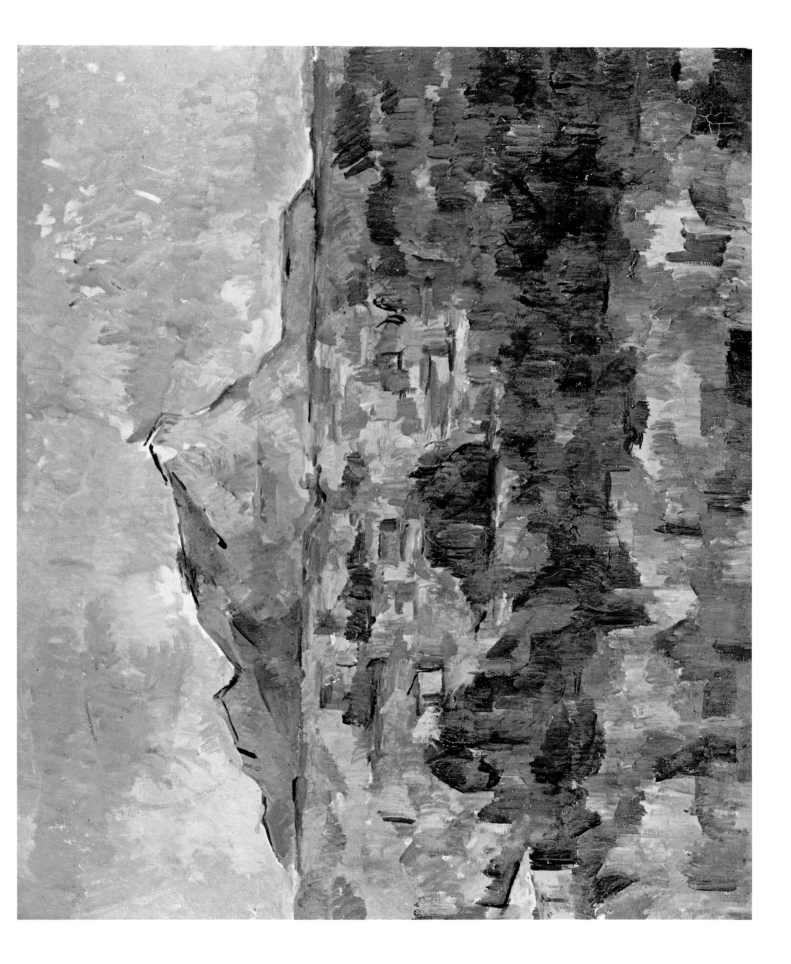

PABLO PICASSO (1881–1973)
Les Demoiselles d'Avignon

1907. Oil on canvas, 244 x 234 cm. Museum of Modern Art, New York, NY

Fig. 15
PABLO PICASSO
Nude Woman Seated
1908. Oil on canvas,
150 x 99 cm.
State Hermitage Museum,
St Petersburg

This seminal work went through several changes in the numerous sketches Picasso made for it in the spring of 1907. Initially there were also to have been two men in the work: a medical student standing on the left and a sailor seated in the middle. In the subsequent development of the composition they were removed, and the final picture was painted in June–July 1907 with only the five original female figures. The painting in fact shows five prostitutes, and the title given to it by the poet and critic André Salmon in 1916, when it was first exhibited publicly, was derived from a brothel on the Carrer d'Avinyo (Avignon Street) in Barcelona. The mask-like faces of the two central figures show the influence of Iberian sculpture, which had impressed Picasso at the Louvre exhibition of 1906. The faces of the other three women were repainted, probably in July, after Picasso had visited the ethnographic museum at the Palais du Trocadéro in Paris, where he was especially struck by the African sculpture on display. The heads of the two left-hand figures are particularly reminiscent of African sculpture. Other influences include El Greco (1541–1614) and, in subject-matter, Jean Auguste Dominique Ingres (1780–1867), a retrospective of whose work was held in 1905 at the Salon d'Automne in Paris.

On seeing the canvas in 1907 Braque was so struck by its aggressiveness that he is said to have commented that it is as if 'someone had drunk kerosene to spit fire'. Most of Picasso's friends were baffled, even Apollinaire. Kahnweiler reports that the painter André Derain (1880–1954) told him that Picasso would be found hanging behind the painting, so little was the work understood. It is a mark of Picasso's robust self-confidence that he continued along this route regardless.

The formal qualities of this painting were crucially important for the development of Cubism; the nudes are treated in a structured, geometric way, their bodies twisted into unnatural poses. This is especially true of the figure on the far left and the two on the far right, whose bodies appear unresolved and merge with their surroundings. The background is also treated in a fractured way and is pushed forward into the composition, making the space between the women almost tangible.

Soon after *Les Demoiselles d'Avignon* Picasso painted a number of heavy, block-like figures in 1908 such as *Nude Woman Seated* (Fig. 15), while the immediate impact on Braque's work is reflected in such paintings as his *Large Nude* (Fig. 2). Though undoubtedly an important stimulus for the movement, *Les Demoiselles d'Avignon* is in many respects an untypical Cubist work; its brightly coloured, highly expressive composition and narrative content are at odds with the sober colour and limited subject-matter of the analytical Cubism that evolved from it.

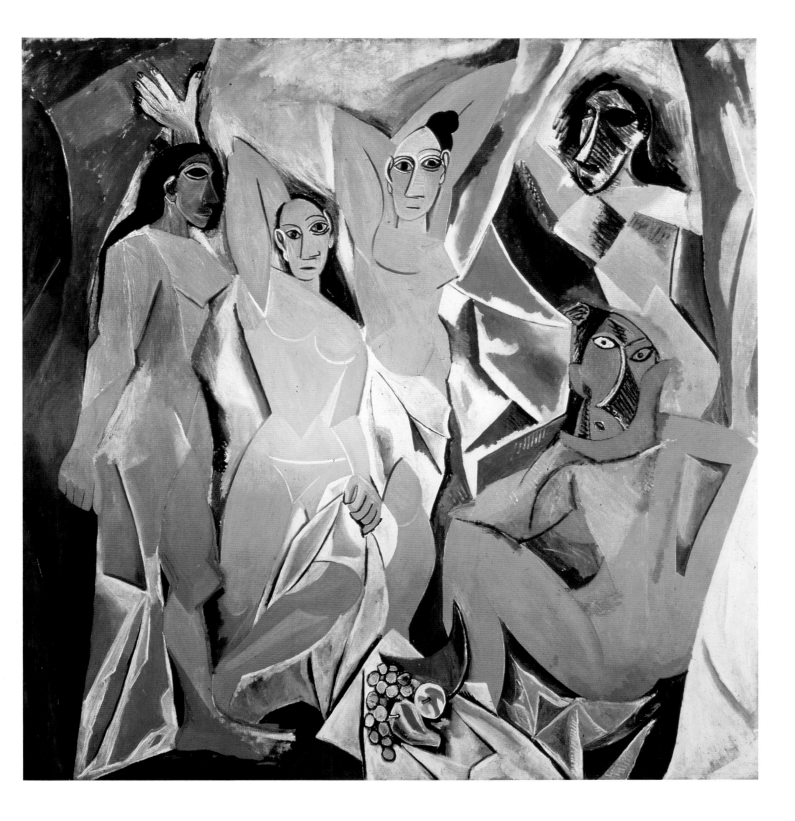

GEORGES BRAQUE (1882–1963)
Harbour in Normandy

1909. Oil on canvas, 81 x 81 cm. Art Institute, Chicago, IL

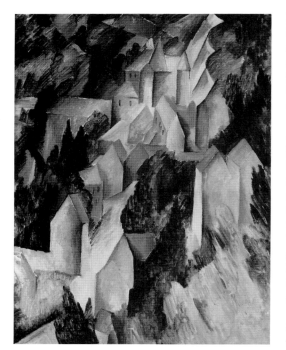

Fig. 16
GEORGES BRAQUE
The Castle at La
Roche-Guyon
1909. Oil on canvas,
81 x 60 cm.
Private collection

In the spring of 1909 Braque visited Le Havre in Normandy, where he had spent much of his childhood. This work was probably executed from memory on his return to Paris and uses the square format he occasionally adopted for works he thought important. It is one of a number of harbour scenes painted at around this time, and is by far the most advanced in Cubist terms; the artist made great progress in his handling of space and volume using facets of colour.

The picture shows two boats sailing into the harbour, one in full sail, with the two jetties marked by lighthouses. Certain aspects are traditional in execution: the lighthouses are naturalistically painted and parts of the boat hulls are modelled. There is also a horizon line, which helps to define space and create a sense of distance. Nevertheless, Braque has used both colour and structure to unify the partly fragmented forms and to give the work a comparatively shallow pictorial space. The sea and sky are of much the same colour and echo certain of the blue-grey forms in the foreground. The diagonals formed by the masts of the two boats are extended into the planes of the sky, and the complex foreground area of the harbour is broken into a number of interlocking facets. As it enters the harbour, the boat on the left produces a ripple of waves at its prow that is formally echoed in the planes of the adjacent harbour wall.

The picture shows much evidence of the influence of Cézanne and reveals the extent to which Braque had mastered the latter's technique of welding elements into a monolithic whole. Soon after painting this work he went to La Roche-Guyon in the Seine Valley, where Cézanne had stayed in 1885. There he painted five pictures of the castle (Fig. 16) in which the buildings provide the strong, geometrical armature for the work, a strategy that proved very useful in the early development of Cubism.

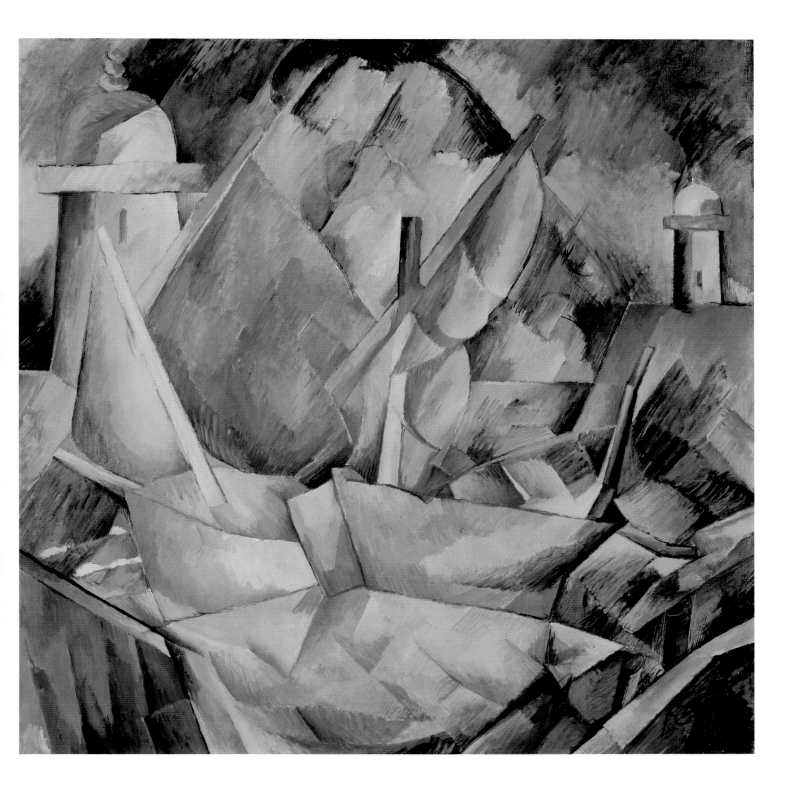

FERNAND LÉGER (1881–1955)
Nudes in the Forest

1909–11. Oil on canvas, 120 x 170 cm. Rijksmuseum Kröller-Müller, Otterlo

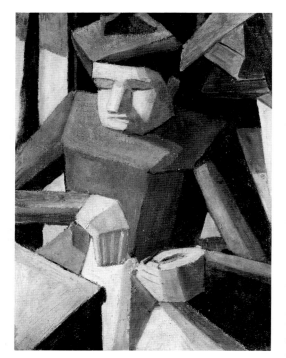

Fig. 17
FERNAND LÉGER
Woman Sewing
1909. Oil on canvas,
73 x 54.5 cm.
Private collection

None of Léger's works from 1908 have survived, but they were probably executed in the Neo-Impressionist manner of those preceding them. In 1909, however, under the influence of Cézanne and Rousseau, the artist began to concentrate on form, as is evident in *Woman Sewing* (Fig. 17), and at some time during 1910 he encountered the work of Picasso and Braque. *Nudes in the Forest* was exhibited in the notorious Room 41 of the Salon des Indépendants in 1911 and shows a distinctively personal style. Léger jumbled the different forms – cylindrical, spherical and conical – in a dramatic way, evidence of the 'battle of volumes', as he later described it. The nudes are merged into the surrounding forest by form and colour; the one on the left wields an axe to chop wood, another lies in the middle, while a third stands on the right. Next to the left-hand figure are the tubular forms of the tree trunks, while in the centre a receding line of small mounds and bushes leads the eye into the distance, so giving the work depth in a traditional fashion. Each of the nudes is of vast, monumental scale; the one in the centre, for example, has a massive torso and arms, together with a hugely oversized right hand.

Like Picasso and Braque, Léger here restricted himself to a narrow range of colours, though he tackled a contrastingly different subject. Rather than the typical still lifes or portraits of these two artists, this work is epic in scope, showing Léger's affinities with Salon Cubism. It draws on the traditional subject of the nude in a landscape, as seen, for example, in Cézanne's 'Great Bathers' series. However, while the conventional treatment shows man in harmony with nature, Léger depicts a hostile struggle between the two; as the left-hand figure furiously chops wood, the one on the right seems twisted around as if defending himself. The central nude reclining on the ground seems almost in danger of being consumed by his surroundings, the dark earthy colours heightening this sense of menace.

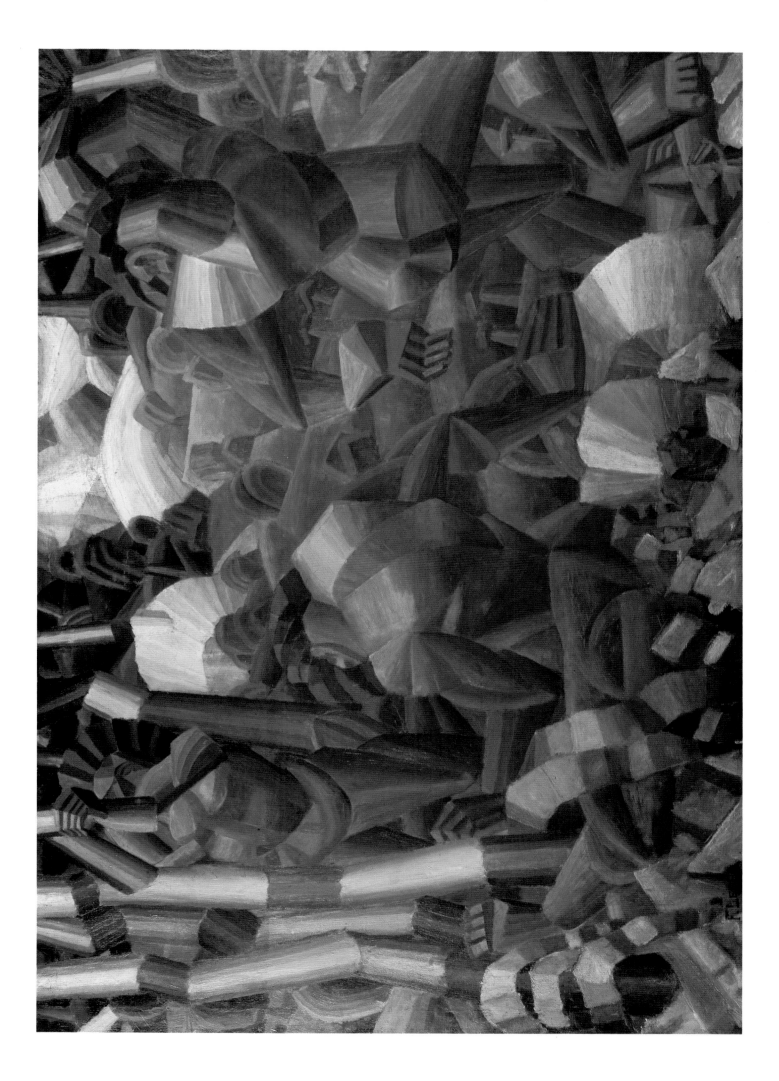

PABLO PICASSO (1881–1973)
Seated Nude

1910. Oil on canvas, 92 x 73 cm. Tate Gallery, London

Though signed and dated 'Picasso [19]09' over ten years later, this work was in fact executed in spring 1910 according to the archives of Kahnweiler. Picasso painted a number of similar canvases at that time, of which this is the most finished, if least complex. The figure is treated in facets but not really fragmented, rather the planes follow the contours and surface of the body, the whole remaining easily recognizable. There is a certain stiffness in the pose, especially evident in the arms, which makes the figure resemble a statue. Picasso has not splayed out or flattened the nude and it is seen essentially from one viewpoint, though certain parts of the figure are twisted as if seen from a slightly different angle. Further, the figure is consistently lit from the top left, throwing it into relief against the background. While the nude retains the sculptural monumentality found in preceding works, the pictorial space is flattened through the connection made between the colours and forms of foreground and background.

In many ways the painting consolidates earlier developments, exercising Picasso's ability to treat forms – even human forms – in terms of geometrical facets. By comparison with Braque's works of 1909 (see Plate 4) this painting might seem timid, though this could be attributed to the difficulties of the subject-matter, which lends itself less easily to the flat, geometric treatment that Braque applied to his landscapes.

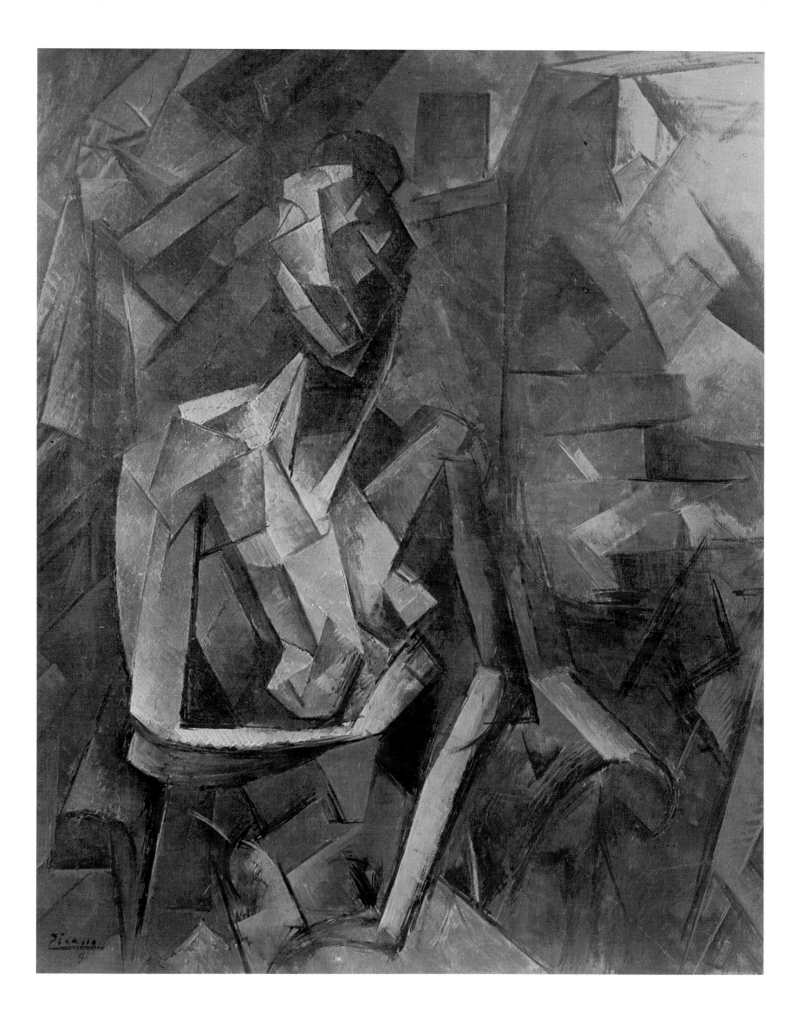

GEORGES BRAQUE (1882–1963)
Violin and Pitcher

1910. Oil on canvas, 117 x 73 cm. Kunstmuseum, Basel

This is one of a group of still lifes painted in 1909–10, in which Braque greatly expanded his Cubist vocabulary. The objects are wholly fragmented into colour planes and pieced together so that the image is formally unified into a pattern of abstract planes. Particularly evident is the use of multiple viewpoints; the scroll of the violin is twisted round to show the side, though the rest of the violin is seen broadly from the front. The bottom of the instrument is also splayed forward, while the S-shaped sound holes seem to float on the front. The treatment of the pitcher emphasizes the Cubist technique of flattening out elements; its top edge has been forced inwards as has the base, so that the whole object is compressed along a vertical axis.

Like the slightly earlier *Violin and Palette* of 1909 (Solomon R Guggenheim Museum, New York) there is a *trompe l'œil* nail with its shadow painted at the very top. However, in contrast to the latter work it has no logical function here, and rather serves to highlight the generally anti-naturalistic technique and to indicate that there are various ways of depicting objects. Braque uses a similar device just below the nail, where the top corner of the book, or sheet of paper, is folded down so that it throws a shadow, paradoxically giving solidity to a flat object.

The still life was always a favoured genre for Braque and it continued to fascinate him throughout his life (it was less dominant in Picasso's work, which was focused more on the figure). Indeed, he came to prefer still life to landscape, which had been an important part of his earlier output, stating that he found a 'more objective element in still life than in landscape'. The widespread apearance of musical instruments in his (and Picasso's) still lifes was explained by him thus: 'I painted a lot of musical instruments, first of all because I was surrounded by them and also because their forms, their volume, came into the ken of the still life as I understood it.' In addition, Braque played the violin and accordion and had taken flute lessons as a young man in Le Havre, while various composers such as Igor Stravinsky, Edgar Varèse and Florent Schmitt were associated with Cubist circles. As the most abstract of art forms, the references to music also emphasize the Cubist rejection of naturalism.

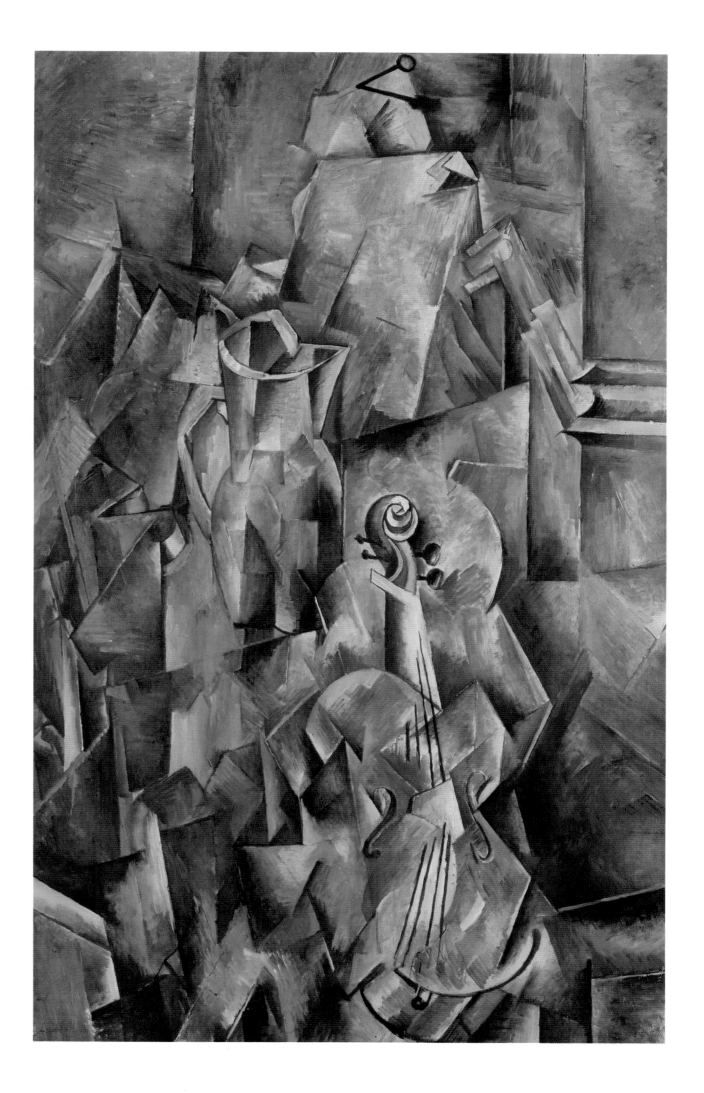

GEORGES BRAQUE (1882–1963)
Woman with a Mandolin

1910. Oil on canvas, 92 x 73 cm. Bayerische Staatsgemäldesammlungen, Munich

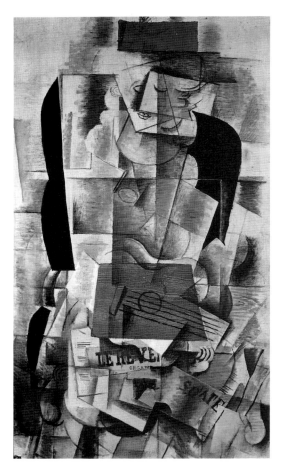

Painted in Paris in the spring of 1910, this is the first Cubist work to use an oval format, and very shortly afterwards Picasso executed an oval work of the same subject. The format was thereafter used quite frequently by both artists. By virtue of its rarity in art, the unusual shape draws attention to the canvas and so highlights the object quality of the picture. Here it also echoes the form of the composition, framing it better than would a rectangular canvas.

The woman is depicted against an almost flat background that emphasizes the solidity of her figure. Some of the planes that describe her form spill beyond her outline, a strategy later used increasingly often to blend objects with each other and with their surroundings. Greatest attention is given to the head and arms of the woman herself. The line of her nose is highlighted, as are her eyes and mouth, while her few curls of hair contrast with the linear structure of the work. The most notable feature of the mandolin is the large, dark sound hole; the few strings are repeated in the lines of the dress at the bottom. The left hand of the woman, by implication on the fingerboard of the mandolin, in fact rests on a blank plane, of which only the lower edge is detailed.

The expected curves of both the woman's body and the mandolin are dissolved amid the severe Cubist structure. All that remains is the circle of the soundhole, which is given a sexual connotation. A related but more overt device is found in the *Woman with a Guitar* (Fig. 18) in which, below the instrument, is a painted reproduction of a newspaper title, with the words curtailed to read 'LE REVE ORGAN[E]': the dream organ.

Fig. 18
GEORGES BRAQUE
Woman with a Guitar
1913. Oil and charcoal on canvas, 130 x 73 cm.
Musée National d'Art Moderne, Centre Georges Pompidou, Paris

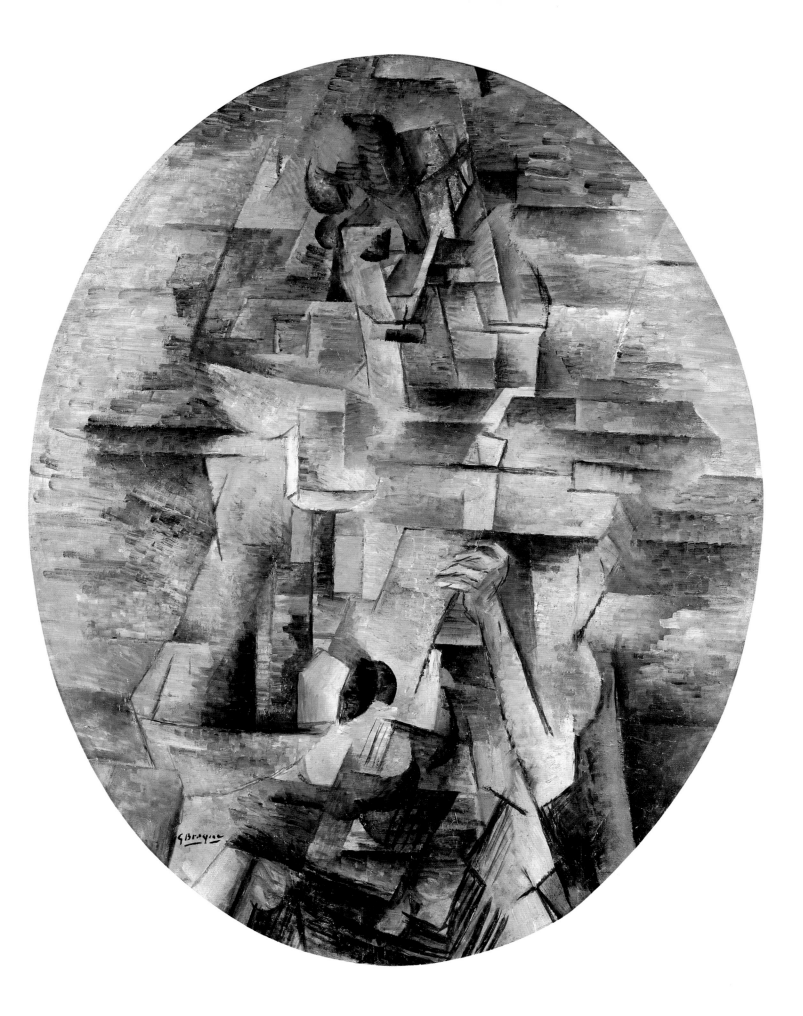

PABLO PICASSO (1881-1973)
Portrait of Ambroise Vollard

1910. Oil on canvas, 92 x 65 cm. Pushkin Museum, Moscow

Ambroise Vollard had been Cézanne's dealer in his later years and greatly contributed to the establishment of the artist's reputation. In 1901 he mounted a joint show of work by Picasso and the Basque artist Francisco Iturrino (1864–1924), and a long association between the dealer and Picasso then began. In 1906 Vollard bought 20 of the artist's early canvases and he cleared out his studio again in 1907. Among his later purchases was a group of sculptures, including *Head of a Woman (Fernande)* (Fig. 5). Like Cézanne, Vollard was a difficult character and when in a bad mood would apparently sulk in the doorway of his gallery putting off all but the most insistent customers. He was also very selective in showing the works he owned, such that, though the money from the 1906 sale was extremely welcome to Picasso, the artist was a little sad that his pictures would be mostly hidden from view.

This portrait was begun in the spring of 1910 in Paris and probably not finished until the autumn of that year. Fernande Olivier, Picasso's mistress at the time, said that its progress 'dragged on for months'. Curiously there was a similar situation with Cézanne's *Portrait of Vollard* of 1899 (Petit Palais, Paris) in which, after innumerable sittings, the artist declared himself satisfied only with the painting of the dealer's shirt front. There is a tension implicit in the idea of a Cubist portrait, especially at this stage of Cubism: objects are invariably so fragmented and generalized as to be scarcely recognizable. Nevertheless, Picasso here perfectly managed to capture the likeness of the dealer, with his characteristically gruff demeanour.

The Cubist style is most evident in the treatment of the background and Vollard's torso, which is merged into a smooth pattern of interlocking facets. The face stands out both through its contrasting, brighter colours and greater detail: eyes, nose and mouth are all visible as is Vollard's distinctive, stubbly, white hair. A process of selection is, however, still evident, the striking fidelity of the image being a reflection of Picasso's great ability as a caricaturist in which the essence of a face has to be captured with few details. Braque acknowledged this gift when he commented that whenever he painted figures 'it was as though they were still lifes' whereas Picasso 'always did real portraits'.

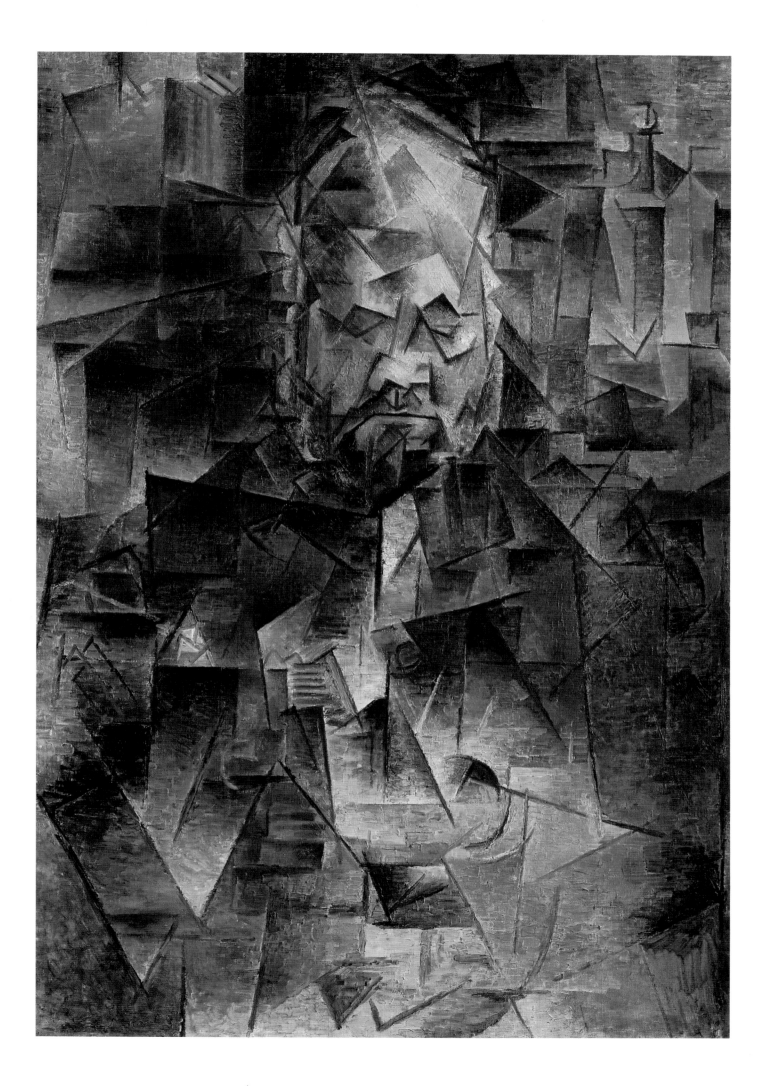

10 GEORGES BRAQUE (1882–1963)
Woman Reading

1911. Oil on canvas, 130 x 81 cm. Ernst Beyeler Collection, Basel

From August 1911 to January 1912 Braque was in Céret in the south of France. Picasso was also there from July to September 1911. The period was fruitful for both artists and it was here that Braque produced this work, among others. He mentioned the painting in several letters to Kahnweiler and was still working on it in late November. In comparison with his preceding works it is considerably more difficult to read. Unlike *Woman with a Mandolin* (Plate 8) the figure is not set against a flat background, rather the entire canvas is covered in a uniform lattice of black lines. The brevity of notation and prominent structure reflect the Cubist aim of creating an art parallel to reality, as Braque explained in 1910: 'I couldn't portray a woman in all her natural loveliness. I haven't the skill. No one has. I must, therefore, create a new sort of beauty, the beauty that appears to me in terms of volume, of line, of mass, of weight.' This austere notion of beauty is clearly evident here. Given the title, we might expect an intimate, perhaps sensual image, yet instead we are offered grey-toned geometry.

Amid the network of straight lines, occasional curves appear that suggest those of the human body. The precise location of the woman, not otherwise obvious, is indicated by the two containing lines that rise from the centre of the canvas and converge towards the top. The woman's head is marked by a few curls of hair, but no facial features are added. Her clothes are indicated by what seem to be two braid links on her front, while the chair is signified through an armrest and the two sides of the chair-back. What the woman is reading is not made clear. As the viewer of the picture is invited to piece together the various pictorial signs and notations, so we might imagine the woman doing likewise while reading, thus making subject and style peculiarly well matched.

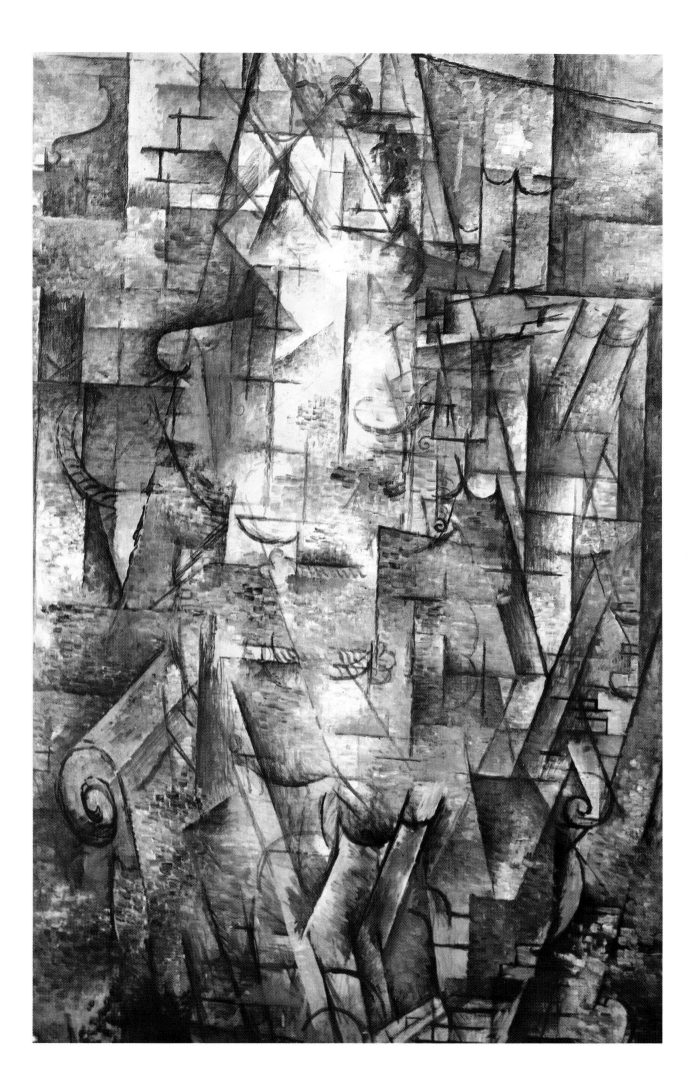

FERNAND LÉGER (1881–1955)
The Wedding

1911–12. Oil on canvas, 257 x 206 cm. Musée National d'Art Moderne, Centre Georges Pompidou, Paris

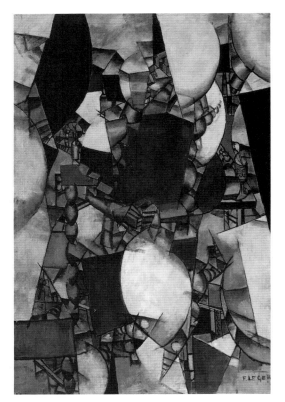

Fig. 19
FERNAND LÉGER
Woman in Blue
1912. Oil on canvas,
193 x 132 cm.
Kunstmuseum, Basel

Exhibited at the Salon des Indépendants, this painting shows how far Léger's work had developed since *Nudes in the Forest* (Plate 5). Space is distorted, forms are fragmented and abstract elements have appeared. Possibly based on the marriage of his friend André Mare, the central axis depicts a wedding procession and incorporates splintered images of figures. The bride's head, with curled hair, is in the centre above an area of white, flat planes, the curved forms of which suggest a female nude. To the right of the procession are partial views of landscapes and buildings, each seen from a different angle. In between these and down the left-hand side of the canvas are interlocking abstract planes that reflect Léger's desire for a 'pure painting' freed from imitation, as well as adding to the spatial complexity of the work. The more angular forms on the left create the dynamism Léger favoured in his pictures of this period, while the interpenetration of the pictorial elements reflects the influence of Simultanism. More specifically, the painting relates to Jules Romains' Unanimist philosophy, through both its focus on a crowd and the blending of the individual figures into a single mass.

In many respects this picture is similar to Picasso and Braque's works, but again is on a much larger scale with more ambitious subject-matter. Further, colour plays a greater role – there are reds, greens and blues – and at the sides these melt away in places to suggest atmosphere. In comparison with *Nudes in the Forest* the pictorial space is much flatter and this is enhanced by both the abstract planes and the vertical depiction of the procession without any spatial recession.

Léger's move towards abstraction is taken a stage further in the *Woman in Blue* (Fig. 19) in which the large, flat planes dominate, almost concealing the image of a seated woman. The process is completed in the wholly non-figurative 'Contrasts of Form' series of 1913–14. Léger justified this development in a published lecture of 1913, *The Origins of Painting and its Representational Value*, claiming that 'the realistic value of a work is completely independent of all imitative quality.'

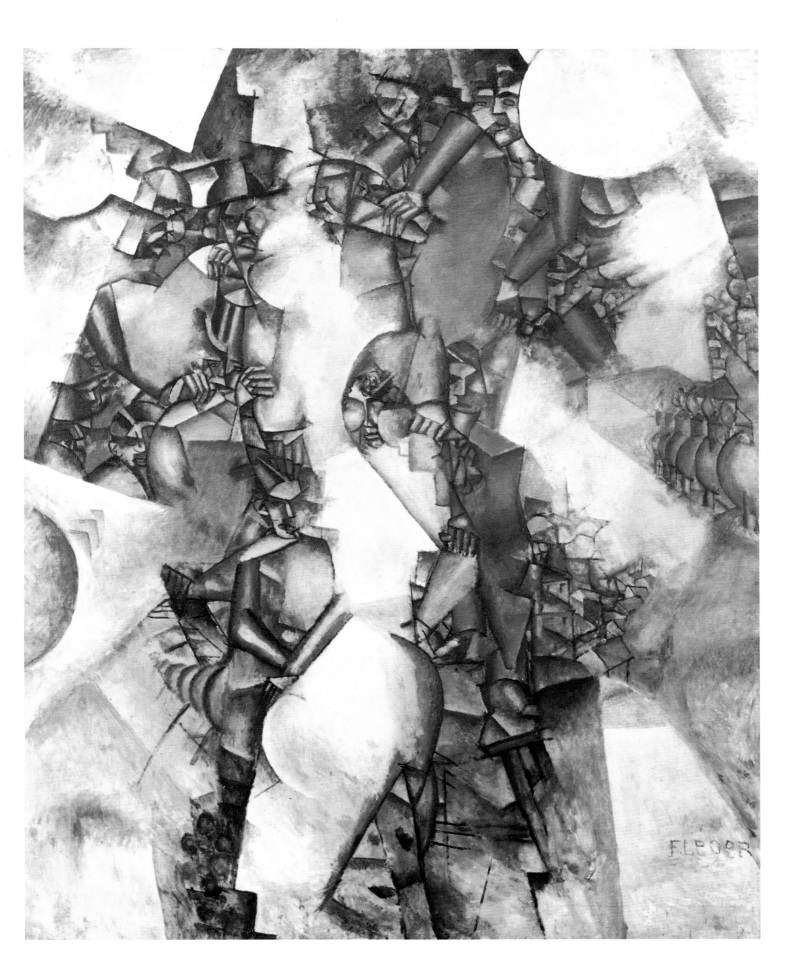

MARC CHAGALL (1887–1985)
Homage to Apollinaire

1911–13. Oil and powdered gold and silver on canvas, 200 x 189.5 cm. Stedelijk Van Abbemuseum, Eindhoven

Chagall moved to Paris from Russia in 1910 and soon became aware of Cubism. Though its austere intellectualism was not in tune with his more poetic approach to art, it nevertheless influenced a number of his works of 1911–13. This extremely dense picture is replete with symbolism, reflecting Chagall's interest in both the Kabbala and alchemy. In the centre of the work is a hermaphrodite divided at the torso into two halves that represent Adam and Eve, with Eve holding an apple. The whole figure is executed in a dislocated, Cubist manner and alludes to kabbalistic doctrine. According to this, the relation between the sexes symbolizes that between Man and God, and the division between male and female must therefore be resolved into the perfect unity that existed before the Fall. In the background is a large circular composition, which suggests the colour discs of Chagall's friend Delaunay, but also stands for a clock face, as indicated by the numbers 9, [1]0 and 11 on the left-hand side. Against this, the hermaphrodite seems as if marking out time through eternity. In the top left-hand corner is the fragment of an orange sun, while in the lower left-hand corner is a section of cloud with birds – features that add to the sense of cosmic scope in the work.

The work also refers to alchemy, as is suggested by the use of gold and silver powder, as well as and again by the hermaphrodite, which symbolizes the merging of opposite natures. On the lower left-hand side, around a heart with an arrow in it, is a square of names: Apollinaire, the poet Blaise Cendrars, the German dealer Herwath Walden and Ricciotto Canudo, the editor of the journal *Montjoie!* Each of these represents one of the four elements: air (derived from the name Apollinaire), fire (from 'cendres', the French for ashes – a pun on Cendrars), water (from the French 'eau', meaning water – a play on Canudo) and earth (from 'Wald', the German for wood or forest, to represent Walden). Chagall's signature appears in its French form (Chagall) and also with his first name written in a combination of Latin and Hebrew scripts beside his surname, which is spelled without vowels. The prominence given to letters not only reflects their purported kabbalistic significance but also indicates the impact of Cubism.

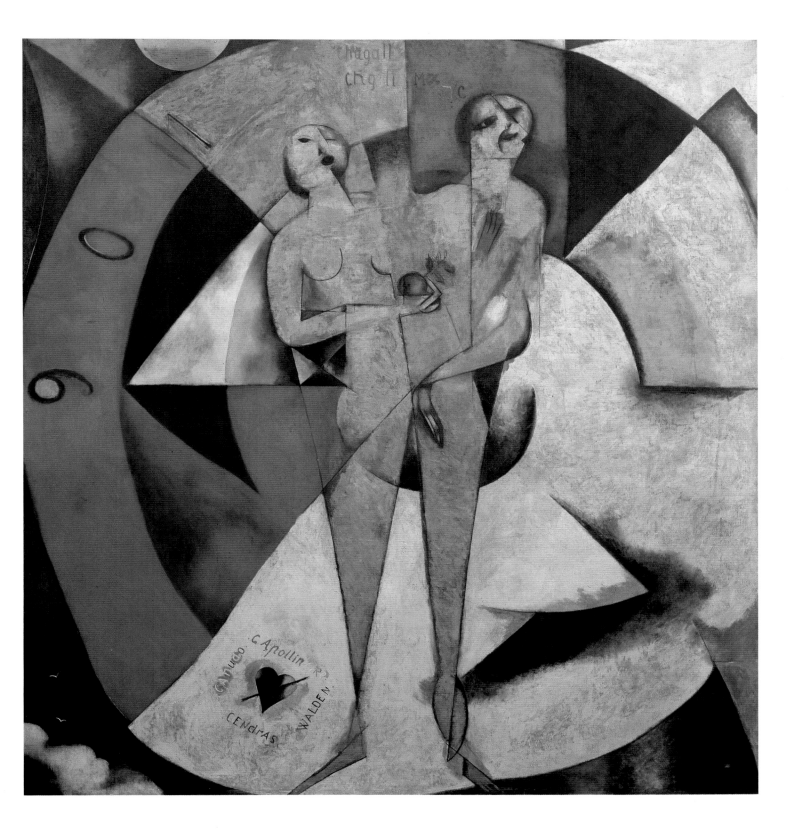

JUAN GRIS (1887–1927)
Portrait of Picasso

1912. Oil on canvas, 93 x 74 cm. Art Institute, Chicago, IL

Fig. 20
JUAN GRIS
The Eggs
1911. Oil on canvas,
57 x 38 cm.
Staatsgalerie, Stuttgart

The *Portrait of Picasso* is one of the three works with which Gris made his debut at the Salon des Indépendants of 1912, marking his public appearance as a Cubist. Designed as a homage to his mentor Picasso, it exemplifies his early Cubist style. By this time Picasso and Braque were both developing synthetic Cubism, but this painting derives from the analytical phase of around 1909 and shows Gris trying to work through Cubism from its beginnings. In his first paintings, Gris made a cautious but very acute examination of Cézanne and Cubism, experimenting with the manipulation of form. In *The Eggs* (Fig. 20), for example, the composition is basically naturalistic but includes geometric elements and dislocations in the contours of objects, as is especially evident in the treatment of the bottle.

In the portrait, though the figure of Picasso is broken up into separate forms, the basic outline is maintained and the resulting image is quite legible. The restricted colour range of the work reflects the austerity of analytical Cubism. While the precision of the forms and the lucidity of the structure are typical features of Gris's mature Cubism, here he still relied on modelling to give volume and also united the composition through the regular effects of light and shadow across the surface. The treatment of the head is as yet a little unresolved, comprising a rather awkward arrangement of elements. Unlike Picasso in his Cubist portraits, Gris resorted to the traditional device of using an attribute to identify the sitter: in this case Picasso holds a palette in his left hand, even though seated.

In later works of this year, following his contact with the Salon Cubists (he also exhibited at the Salon de la Section d'Or in 1912), Gris briefly worked in a style similar to that of Metzinger or Gleizes, using geometric, black outlines as a structural support.

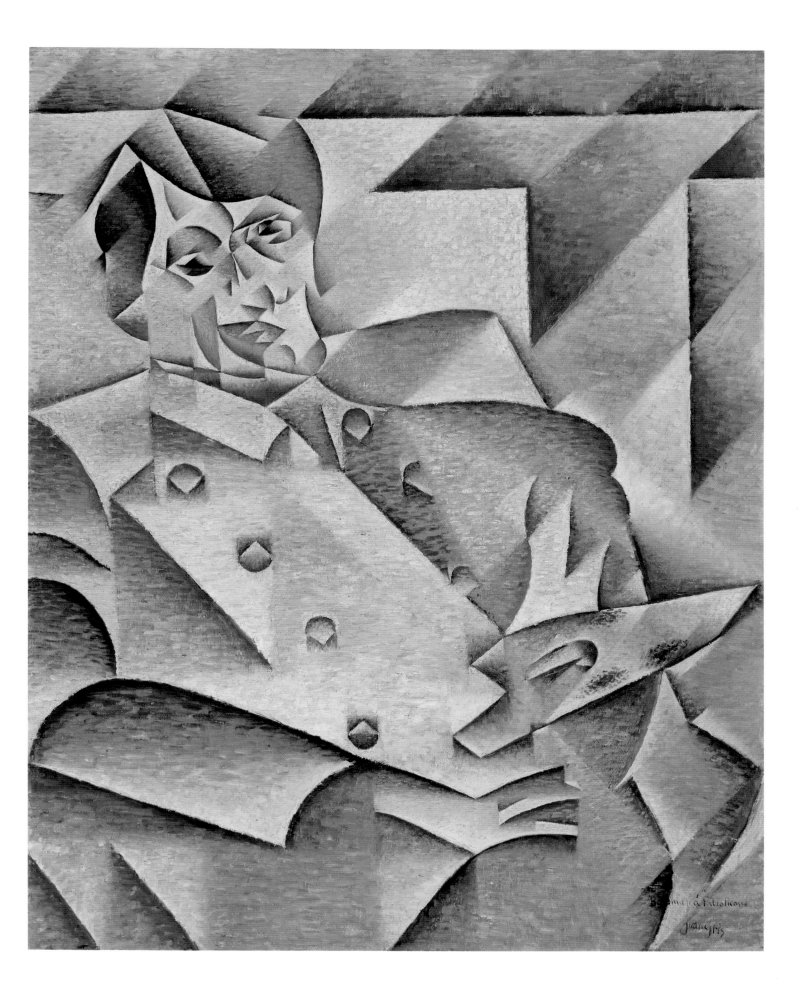

ALBERT GLEIZES (1881–1953)
The Bathers

1912. Oil on canvas, 105 x 170 cm. Musée d'Art Moderne de la Ville de Paris, Paris

Fig. 21
ALBERT GLEIZES
Portrait of Stravinsky
1914. Oil on canvas,
129.5 x 114.3 cm.
Private collection

As a member of the short-lived group, the Abbaye de Créteil (1906–8) Gleizes wished to forge a new style with which to deal with the modern world, one that also emphasized collective activity and the simultaneity of experience. In 1909 he saw Le Fauconnier's portrait of Pierre Jean Jouve (Musée National d'Art Moderne, Centre Georges Pompidou, Paris), which, though merely angular rather than Cubist, greatly inspired him to create a fresh style. He soon became acquainted both with Le Fauconnier and Metzinger as well as other Salon Cubists. From his sculptural, geometric works of 1910 he developed a flatter, more rigidly geometric and structured style. However, the city, which for artists like Léger and Delaunay constituted the quintessentially modern subject, did not appeal to him. Hence, as in this work, he continued to focus on landscapes and workers, which had been the staple of his earlier paintings.

This ambitious picture, exhibited at the Salon des Indépendants in 1912, shows Gleizes' transition to the more formally complex works he produced soon afterwards. The rhythm of forms and colours across the canvas unites the composition and flattens the space, yet elements of traditional perspective remain: the buildings in the background are suitably small in scale while in the middle left, almost invisible, is a tiny figure on a horse riding into the distance. The colour scheme and use of geometrical facets recalls the work of Cézanne, though there is a greater precision and forcefulness in the execution. The epic theme and panoramic scope are typical of Salon Cubism and show Gleizes trying to reconcile past traditions with the demands of the modern world. In the foreground are classically posed female bathers, each engrossed in their own activities, while in the distance are factories belching smoke that blackens the sky. The contrast between the brightly lit foreground figures and the dark background adds an ambivalent note to the work, suggesting that Gleizes' enthusiasm for modernity was lukewarm.

Over the subsequent years Gleizes moved towards a more simplified manner using a small number of flat planes, and his subjects became less panoramic, as in his portrait of Igor Stravinsky (Fig. 21). His paintings from the early 1920s have a strong stylistic resemblance to those of Gris, with whom he shared a similarly rigorous, theoretical approach to art. Following this, he developed a geometrical form of abstraction, while also working with religious subject-matter.

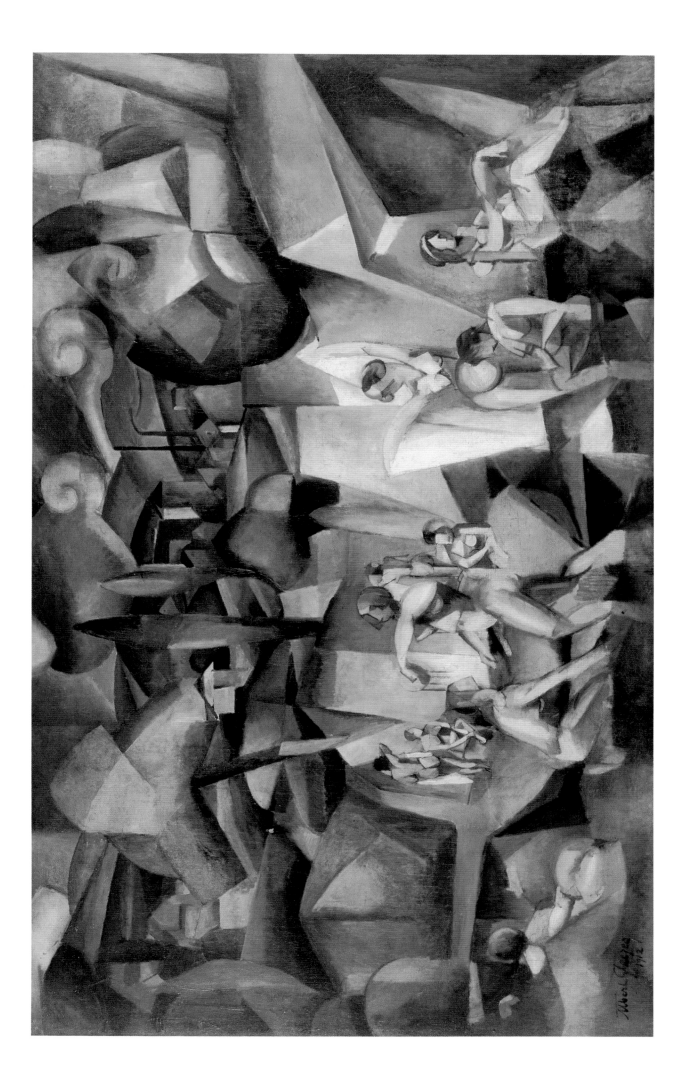

JEAN METZINGER (1883–1956)
Dancer in a Café

1912. Oil on canvas, 146 x 114 cm. Albright Knox Art Gallery, Buffalo, NY

In his 1910 article in the art journal *Pan*, 'A Note on Painting', Metzinger stated that Cubism consisted of a balance 'between the pursuit of the figurative and the mania for the eternal'. The reference to the eternal was a recurrent theme in Salon Cubist circles, spawning an interest in classicism. Many Salon Cubists saw themselves as reviving the French tradition by creating a new style for subjects of the same scope as those used by, for example, Jacques-Louis David (1748–1825) and Ingres.

In *Dancer in a Café* Metzinger took a specifically modern subject, which he highlighted by the emphasis on the fashionable clothing of the figures. The dancer stands on the right holding a bunch of flowers, while to the left are two women and a man at a table, with another man standing behind them. The black lines structuring the composition are also found in other of Metzinger's works of the period. Metzinger picked out certain elements naturalistically, such as the feathers on the seated women's hats, the lace trimming on the dress of the nearest one, and the flowers. The decorative border of the dancer's dress is highly detailed, making it the focal point of the work. Thus, the artist seems to be deliberately contrasting the ephemeral, as symbolized by fashion and the flowers, with the eternal, as represented by the geometry that structures the work. He showed a similar interest in the subject of women's fashion in a number of other paintings of 1912–13. In later works he developed a more synthetic form of Cubism, but by the early 1920s he had abandoned Cubism altogether.

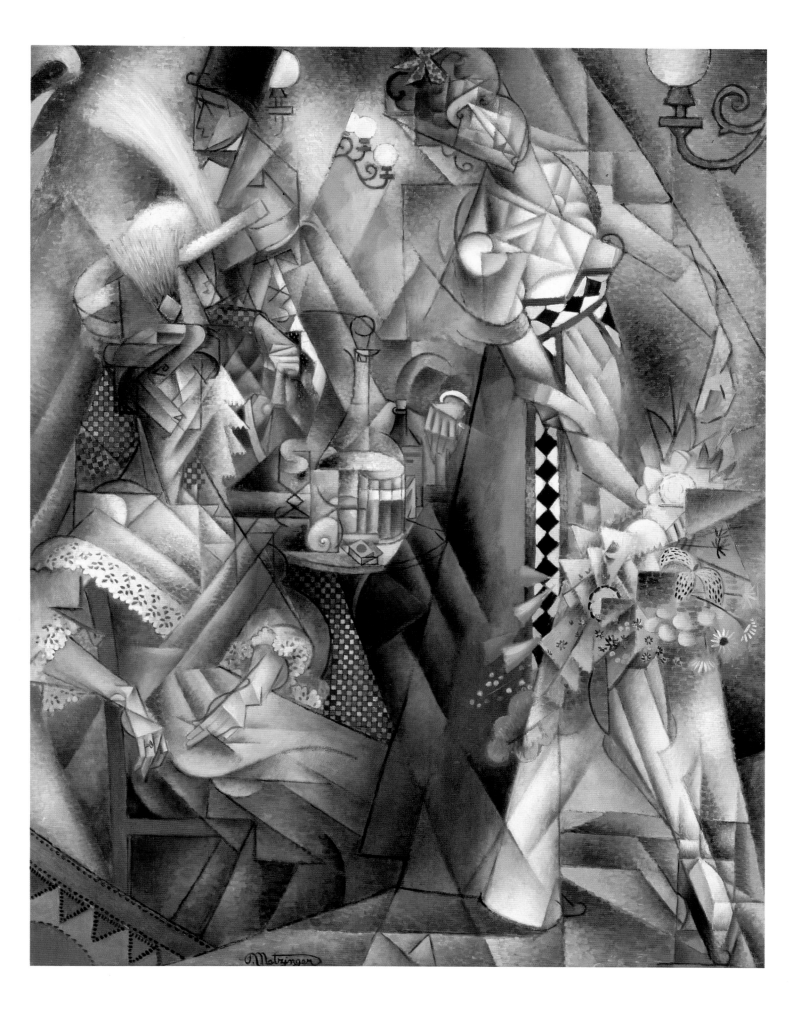

ROBERT DELAUNAY (1885–1941)
The City of Paris

1912. Oil on canvas, 265.5 x 402.5 cm. Musée National d'Art Moderne, Centre Georges Pompidou, Paris

Though dated 1910–12 on the canvas, this work was executed in less than a month in 1912, the wider date range perhaps indicating it to be the culmination of Delaunay's output over that period. The speed of execution is remarkable considering the vast scale of the painting, but it was facilitated by the artist's adoption of a thin, sketchy painting style and the use of elements from earlier works. On the right, the image of the 'Eiffel Tower' next to a building is very similar to that in the Eiffel Tower series of 1910–11, while the left-hand section, framed by a window curtain, is derived from 'The City' series of 1911; the lower part is a quote from Rousseau's *Self-portrait* of 1890, (Národní Galerie, Prague), which Delaunay then owned. In the centre are the Three Graces, based on a photograph of a fresco in Pompeii.

In this work Delaunay attempted to capture the Simultanist understanding of the city through a multitude of different images. For success, the whole must be seen in one instant, and Delaunay thus tried to unify the painting by blending the left- and right-hand figures into their neighbouring areas through colour. However, because this strategy is not altogether effective and also because of the large dimensions, the picture really has to be viewed in parts; it is essentially a triptych on one canvas. It is only the right-hand section, in which the tower and building are fragmented and interlocked, that a genuinely Simultanist impression is made. As in his earlier treatments of this subject, Delaunay used a dynamic, unstable structure and also retained the white circles that stand for the radiating energy of light. The Eiffel Tower symbolized both modernity and engineering skill. Further, it was used as a radio mast, and the idea of such waves travelling endlessly through space had an obvious appeal in the context of Simultanism. The inclusion of the three figures is curious: Delaunay very rarely depicted the female nude, but its regular appearance in the history of art gives the work a link with tradition and thereby, in Simultanist fashion, brings the past into the present. In execution, the faces of the figures, especially the one the right, resemble those in Picasso's *Les Demoiselles d'Avignon* (Plate 3).

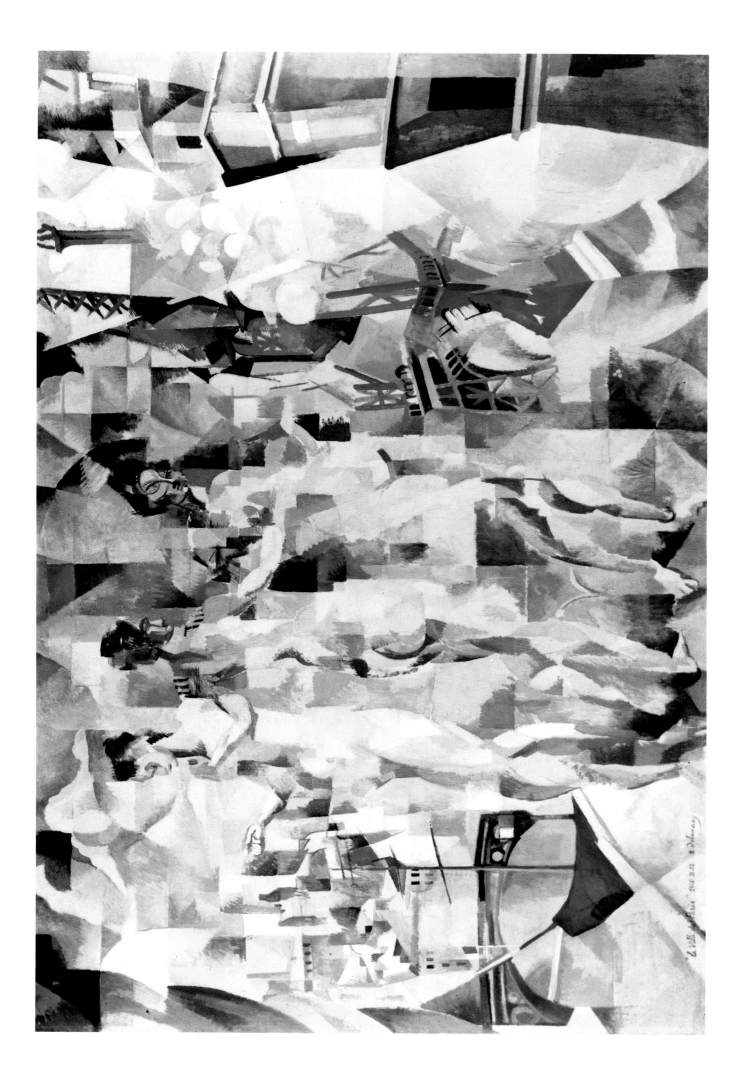

17

ROBERT DELAUNAY (1885–1941)
Windows Open Simultaneously:
First Part, Third Motif

1912. Oil on canvas, 46 x 37.5 cm. Tate Gallery, London

Soon after finishing *The City of Paris* (Plate 16) Delaunay began work on the 'Windows' series, which marked the start of his move towards abstraction. His earlier townscapes had been views from a window, and he now concentrated on the windows themselves, or more precisely on light. In most of the works in this series the only recognizable object is the slender form of the Eiffel Tower; it is here seen in the centre, painted in green. In the 'Windows' series Delaunay again hoped to create works that could be perceived simultaneously, hence the colours are arranged so that they can only be seen together with those around them. The style derives from the Pointillist manner he had employed in earlier works. By greatly expanding the colour blocks, they ceased to be representational and instead become autonomous elements.

Inspired by the effect of light falling on window panes, the 'Windows' series reveals Delaunay's great interest in light and colour – for example, he studied light refraction in prisms and also reflection. He was fascinated by the ideas of Eugène Chevreul, a nineteenth-century French colour scientist, especially by his notion of 'simultaneous contrasts', in which the simultaneous perception of two adjacent colours creates a third. For Delaunay light was the key to understanding the universe, in part because it enabled sight. In 1912 he wrote an essay on the subject, stating that 'Human sight is endowed with the greatest Reality since it comes to us directly from the contemplation of the Universe. The Eye is our highest sense, the one that communicates most closely with our brain and consciousness.'

Like the painter and theorist Wassily Kandinsky (1866–1944), with whom he was in contact at that time, Delaunay associated art with music, trying to manipulate colours in the same way that the composer does musical notes. The supposed relation between the two was part of Symbolist theory and accounts for Apollinaire's choice of the term Orphism (from the legendary Greek musician Orpheus) to describe the art of Delaunay and others. Apollinaire was an enthusiastic supporter of Delaunay's work and in 1912 wrote a poem inspired by the 'Windows', which closes with the suggestive lines: 'The window opens like an orange/ Fine fruit of light.'

MARCEL DUCHAMP (1887–1968)
Nude Descending a Staircase II

1912. Oil on canvas, 146 x 89 cm. Museum of Art, Philadelphia, PA

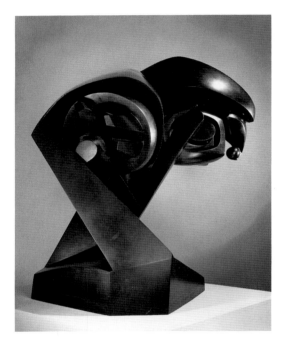

Fig. 22
RAYMOND DUCHAMP-
VILLON
Large Horse
1914. Bronze, h149.9 cm.
Museum of Fine Arts,
Houston, TX

The three brothers Jacques Villon, a painter and engraver, Raymond Duchamp-Villon, a sculptor, and Marcel Duchamp were all involved in the early development of Salon Cubism, and many of the Salon Cubists used to gather at the studios of Jacques and Raymond in the Parisian suburb of Puteaux. Duchamp-Villon's *Large Horse* (Fig. 22) is the most important of his series of sculptures of horses and, using the techniques of both Cubism and Futurism, shows the dynamic form of the horse metamorphosing into a machine.

Duchamp's absorption of Cubism was mixed with an interest in time-lapse photography, as practised by men such as Étienne-Jules Marey (1830–1904) and he thus produced works using sequential, cinematic imagery similar to that adopted by some of the Futurists. *Nude Descending a Staircase II* is one of his most famous works and caused a great sensation at the Armory Show in America in 1913. He made a study for it as *Nude Descending a Staircase I* at the end of 1911 and later also painted both a large and a small replica. This work has a cinematic technique and a restricted tonal range. The artist described it thus: 'Painted, as it is, in severe wood colours, the anatomical nude does not exist, or at least cannot be seen, since I discarded completely the naturalistic appearance of a nude, keeping only the abstract lines of some twenty different static positions in the successive action of descending.' Though idiosyncratic, the painting shows various Cubist concerns. It is therefore rather surprising to learn that when he submitted it for the 1912 Salon des Indépendants it deeply worried the hanging committee, which was still dominated by the Cubists, following their coup the previous year. Gleizes and Metzinger apparently thought it had 'too much of a literary title', adding that in their opinion 'A nude never descends the stairs – a nude reclines.' Pressed to change the title, Duchamp instead withdrew the work altogether. It was, however, shown without opposition at the Salon de la Section d'Or the same year.

Soon after these early Cubist works Duchamp became involved in Dadaism, of which he was one of the most anarchic exponents, and by 1918 had given up painting altogether in favour of sculpture and 'ready-mades' (objects merely chosen by the artist and then exhibited).

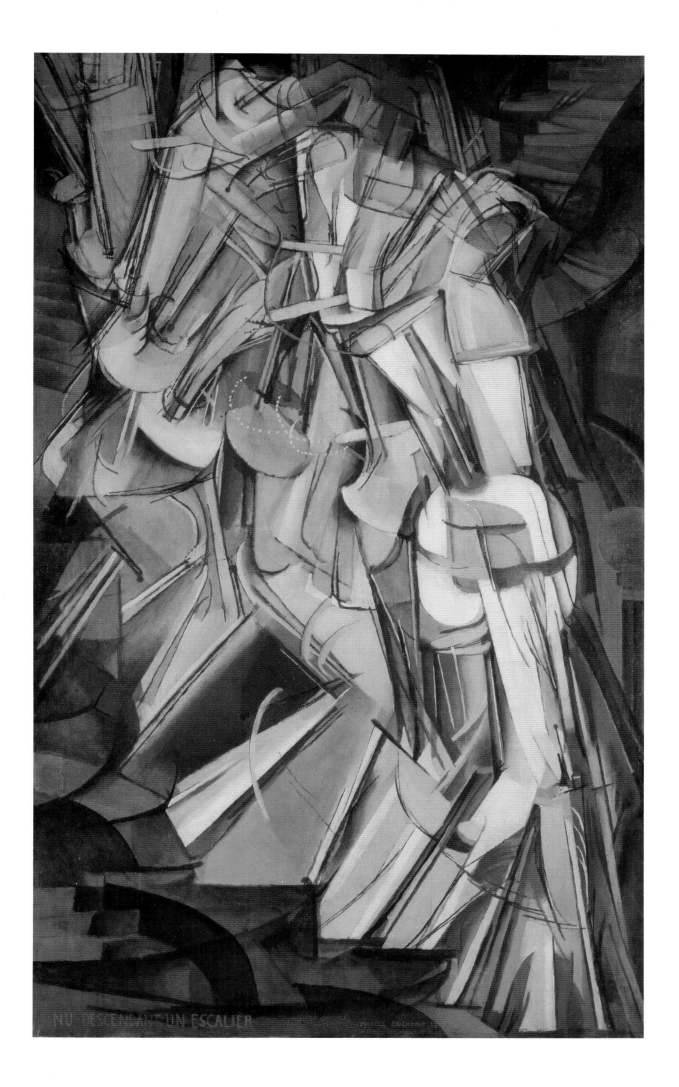

GINO SEVERINI (1883–1966)
Dynamic Hieroglyph of the Bal Tabarin

1912. Oil on canvas with sequins, 160 x 155 cm. Museum of Modern Art, New York, NY

Living in Paris from 1906, Severini became quickly aware of the latest developments in French art. His painting is consequently more Cubist and less bombastic than most Futurist work. This picture relates to the earlier large-scale *Pan-Pan Dance at the Monico* of 1911–12 (location unknown), another evocation of Parisian night-life. It is also connected with the preceding images of dancers, especially the *Blue Dancer* of 1912 (Private collection) which likewise incorporates sequins. The complex interleaving of elements makes the work hard to read but it does create a unifying rhythm across the canvas. In place of any central focus is a general impression of energy and movement, together with the names of dances: 'Polka' in the top left and 'Valse' in the bottom right. The very title of the work suggests that it is intended not as a literal representation of a scene but rather as an arcane hieroglyph that cannot be analysed into parts. Certain elements are legible: for example, the man with a top hat, bow tie and monocle on the right in the foreground and various women's heads along the top. There are also some curious details such as, next to the word 'Bowling', the naked woman astride a pair of scissors at the top left, adding a blatantly sexual note to the image. This is further reinforced by the head of a black cat on the right and perhaps by the black figure riding a horse in the middle of the canvas, at the top. The treatment of certain details of the women's dresses, which are brought to life with naturalistic touches or by the addition of sequins, is similar to that adopted by Metzinger in *Dancer in a Café* (Plate 15).

Severini's later *Train in the City* (Fig. 23) is more typically Futurist in its aggressive dynamism and subject-matter, reflecting the Futurist fascination with speed and technology. After the war Severini was affected by the 'return to order' and also by Gris's form of Cubism.

Fig. 23
GINO SEVERINI
Train in the City
1913. Charcoal on paper,
49.8 x 64.8 cm.
Metropolitan Museum of
Art, New York, NY

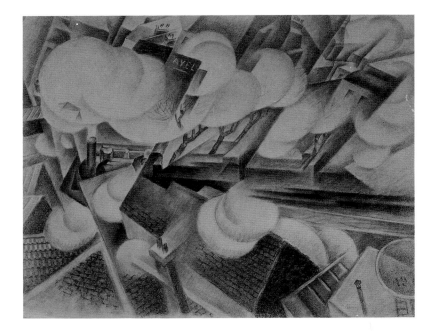

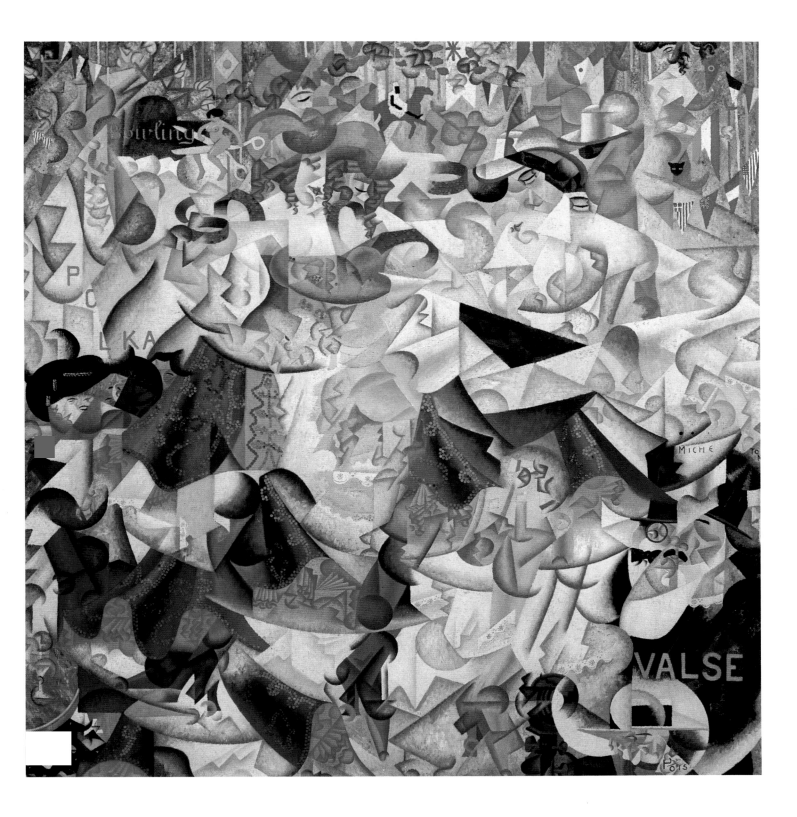

NATHALIA GONTCHAROVA (1881–1962)
Electric Lamps

1912. Oil on canvas, 105 x 81 cm. Musée National d'Art Moderne, Centre Georges Pompidou, Paris

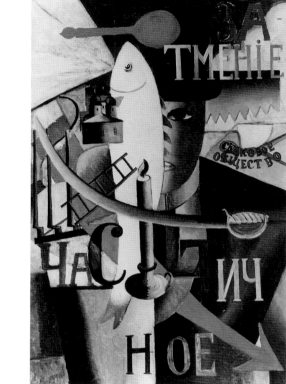

Fig. 24
KASIMIR MALEVICH
An Englishman in
Moscow
1914. Oil on canvas,
88 x 57 cm. Stedelijk
Museum, Amsterdam

This is one of a group of works that Gontcharova painted of electrical machines. Their implicit energy and modernity are well suited to the ideals of Cubo-Futurism, that peculiar hybrid found in Russia. Gontcharova believed that machines were somehow animated in the same way as living things, almost with a will of their own. Hence the emphasis in this picture is not so much on sharp, clean forms but on the flowing, organic lines of a living being. The splintered light rays emanating from the lamps indicate the influence of Rayonism, defined by the poet Vladimir Mayakovsky as a 'Cubist interpretation of Impressionism'. In full-blooded Rayonism, such effects break up the whole surface of the picture into a series of sharp fragments.

Malevich responded differently to developments abroad. Whereas works such as *The Knife Grinder* (Fig. 11) of 1913 draw primarily on Futurism, a number of slightly later works, such as in *An Englishman in Moscow* (Fig. 24) of 1914, derive from synthetic Cubism. In this painting Malevich brought together a disparate range of objects, abstract elements and letters. The seemingly nonsensical collection of a spoon, fish, church, sabre, candlestick and an Englishman in a top hat reflect Malevich's theory of 'alogism'. This was an attack on rationality and logic, which he thought bourgeois and outdated, and was typical of the literary Futurism of such poets as Velimir Khlebnikov and Alexei Kruchenikh. The figure in this painting is in fact based on Kruchenikh, who was thought to look like an eccentric Englishman. The words only add to the confusion, reading at top left 'Eclipse', to the right of this 'racing club' and at the bottom 'partial'. Malevich's approach contrasts with that of Picasso or Braque in their synthetic work: whereas they manipulated abstract elements to invest them with meaning, Malevich brought together naturalistic objects and reduced them to nonsense, a strategy that looks ahead to Surrealism.

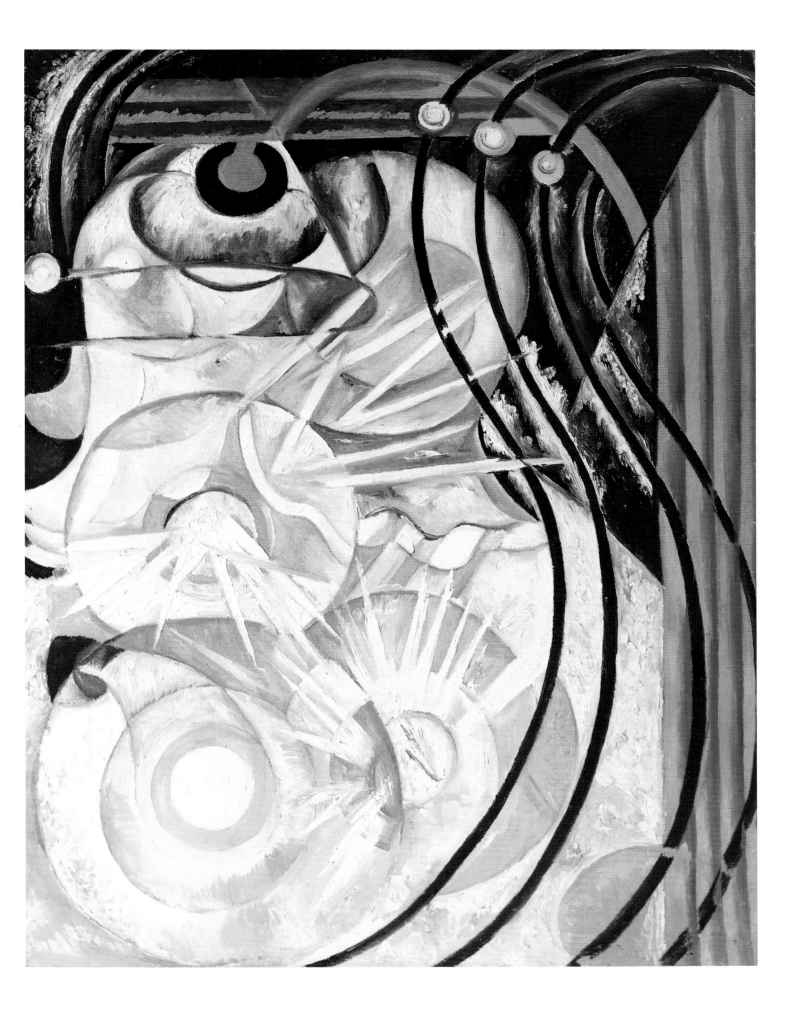

21

PABLO PICASSO (1881–1973)
Bowl with Fruit, Violin and Wineglass

1912–13. Pasted paper, watercolour, chalk, oil and charcoal on cardboard, 65 x 50.5 cm.
Museum of Art, Philadelphia, PA

This is one of Picasso's most sophisticated *papiers collés*, full of complex spatial and visual play as well as verbal wit. It shows a still life on a table in front of which is a chair whose back is seen in the lower left. The table edge is indicated by the curve in the lower half of the work, the piece of newspaper that extends below it being a table-cloth. The table itself is comprised of both the white curved segment and the piece of *faux bois* paper above it. In the centre of the table is a violin treated in a complex, synthetic way. Its main body is made from the piece of blue paper on which are inscribed the strings and the S-shaped soundholes. Above the blue area is the neck, which is composed of white and black strips that indicate light and shadow, and at the end of these is the flattened scroll drawn on the newspaper. The body radiates out on the left into two rounded sides, one in *faux bois* to mimic the real material.

To the right of the violin is a large sheet of newspaper, onto which is pasted another with a drawing of a glass on it. By setting this second piece at an angle to that below, Picasso suggests the refraction of light through the glass. To the left of the violin is the fruit bowl, the base of which is represented by both the white rectangle and the curved outline formed by the side of the violin and the shaded sections below. The bowl itself is indicated by more newspaper, while the fruit is depicted with naturalistic botanical lithographs stuck onto the newspaper. Picasso emphasizes the deceit here: the illusionism of the fruit is undermined by overlapping the cut-out sections, so obscuring parts of the images. The very fact of using these 'ready-made' images attacks the traditional importance laid on technique: why spend time carefully painting fruit when one can simply cut out reproductions? In the top right is a fragment from the word 'Apparition'. This was taken from an article about a spiritualist seance, and so draws a whimsical analogy between the materialization of spirits and the emergence of objects from paper fragments. At the bottom, upside down, is the phrase 'La Vie Sportive' – the sporting life – a reference to the playfulness of Cubism.

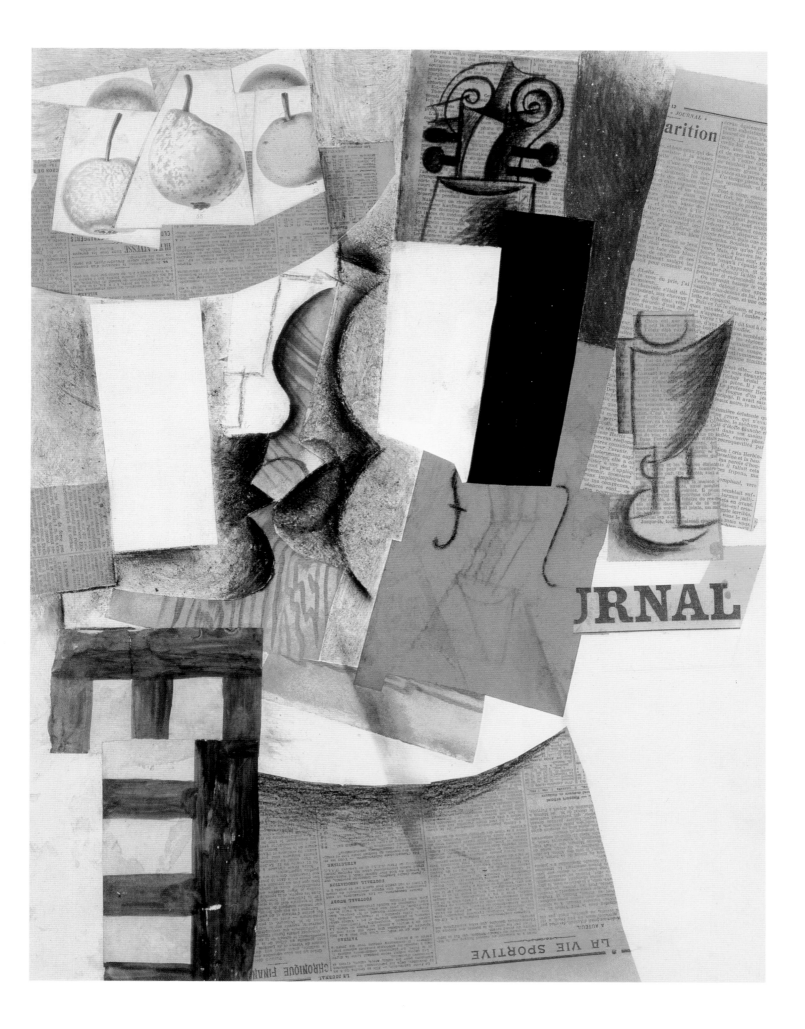

22 GEORGES BRAQUE (1882–1963)
Fruit Dish, Ace of Clubs

1913. Oil, gouache and charcoal on canvas, 81 x 60 cm. Musée National d'Art Moderne, Centre Georges Pompidou, Paris

Braque closely based this painting on his first *papier collé*, *Fruit Dish and Glass* of 1912 (Private collection), and both were formerly owned by the dealer and collector Wilhelm Uhde. The playing cards are additions not found in the earlier *papier collé* and they crop up in several subsequent Cubist works. For the *faux bois* paper in *Fruit Dish and Glass* Braque here substituted wood effect painting, though he retained the rectilinear, cut-out appearance of these elements.

This work perfectly illustrates the synthetic Cubist method of making abstract elements signify objects through positioning and the addition of details. The wood effect strips at the top are made to suggest the wood panelling of the wall, while at the bottom is the drawer of the table with a circle drawn in it; the rest of the table is represented by the large black areas. The bunch of grapes (naturalistically modelled) and other fruit hover on the surface of the canvas rather than sitting in the fruit dish; the sloping sides of the dish are added in charcoal. Also spatially unconnected is the newspaper on the left-hand side, a few letters of which are clearly visible. The words in the centre, again perhaps those of a newspaper, seem to have been deliberately curtailed, the ending being erased by a brush of paint, so as to enhance the enigmatic aspect of the work. The whole composition is made forcefully flat by the planes of black and *faux bois* paint and also through the structure – both the drawer and table are lifted upwards as if seen directly from above.

The inclusion of the playing cards adds to the quotidian nature of the rest of the still life, indicating the daily life of the artist and his colleagues (the original *papier collé* included the words 'BAR' and 'ALE', making this clear.) The cards also highlight the element of play in Cubism, which is further underlined by the connection with a *papier collé*: the wood effect paint is an imitation of wood effect paper which, in turn, is used to indicate wood itself.

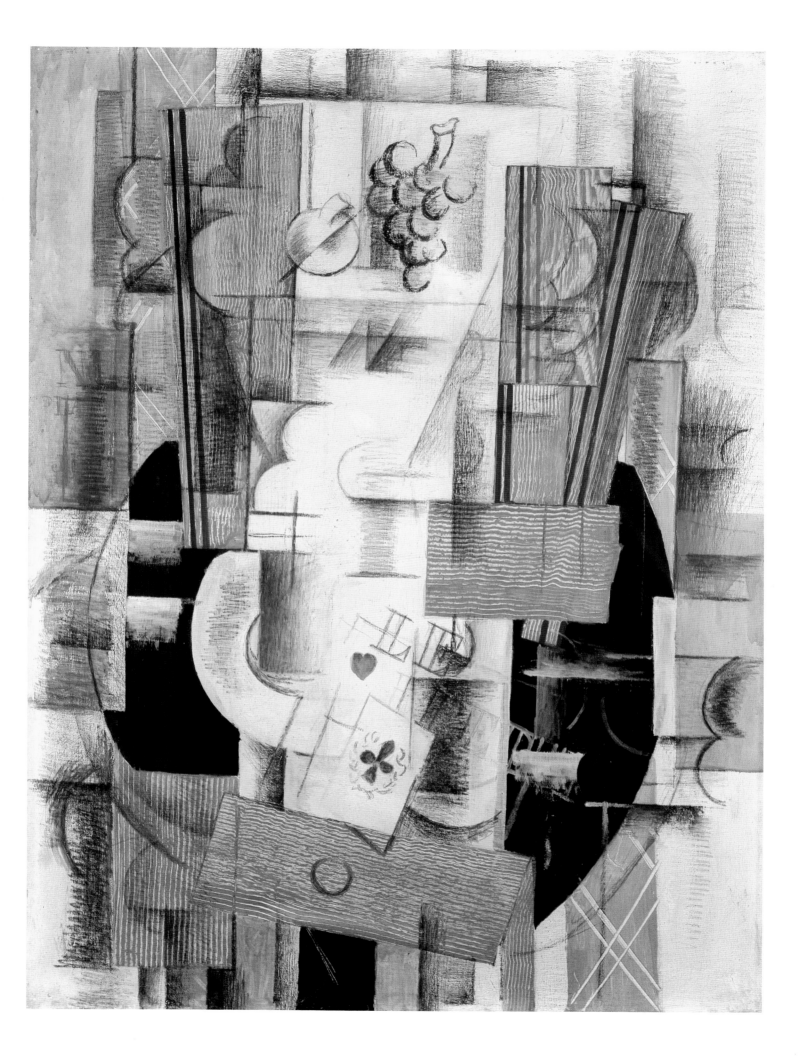

23 PABLO PICASSO (1881–1973)
Bottle of Vieux Marc, Glass, Guitar and Newspaper

1913. Pasted paper and ink on paper, 46.5 x 62.5 cm. Tate Gallery, London

This *papier collé* was produced while Picasso was in Céret in the spring of 1913 and includes fragments from both an old issue of *Le Figaro* from 28 May 1883 (the date of which can be seen) and, at the top and bottom, an embroidery transfer motif. Further pieces of the same newspaper were used by Picasso in a few other *papiers collés* of this time and the embroidery motif was likewise used in another contemporary work. The ink drawing is used to create the details of the bottle, glass and guitar and to define the edge of the table. The bottle has been cut in such a way as to appear slightly rolled out and as if caught by the light on the left-hand side. The transfer motif evokes embroidery itself, just as the cut-out bottle, glass and guitar also suggest their real counterparts.

The first page of the newspaper used in this composition was devoted to the coronation of Tsar Alexander III in Moscow. It has been suggested that Picasso chose to use this because 1913 was the 300th anniversary of the Romanov dynasty, an event that had received much publicity. The obliqueness of this reference – only the top of one of the relevant columns is shown – is typical of the private nature of many Montmartre Cubist works, especially those of Picasso. The label on the bottle, half concealed and handwritten, leaves the single word 'Vieux' ('old'), perhaps a deliberate allusion to the age of the newspaper. It must furthermore have appealed to Picasso to use something from so distant a period, thus heightening awareness of the artistic revolution that he had done so much to bring about in the meantime.

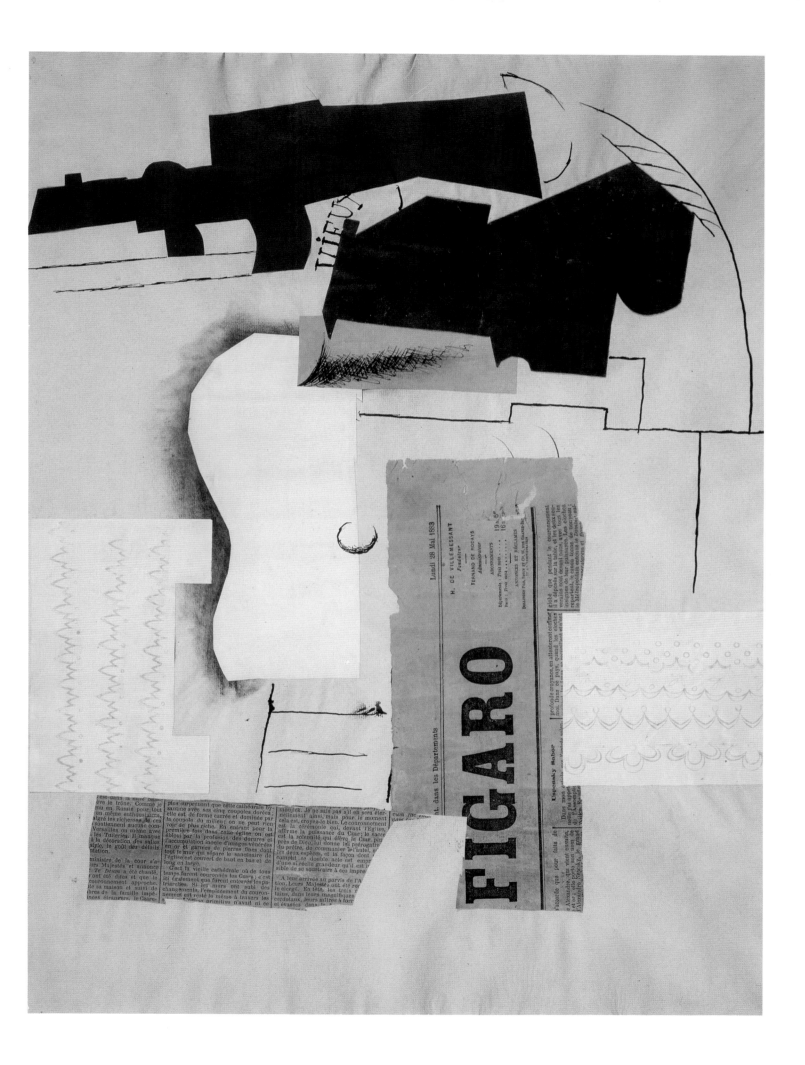

PABLO PICASSO (1881–1973)
Guitar, Gas Jet and Bottle

1913. Oil, sand and charcoal on canvas, 68.5 x 53.5 cm. Scottish National Gallery of Modern Art, Edinburgh.

Though in fact a painting, this work draws on the principles of *papier collé*, and uses flat areas of colour for the guitar, its volume suggested by the apparent overlap of the planes. Picasso adopted different styles for the various elements in the work, from the rich tactile surface of the sand and paint area on the right, to the spare outlines of the gas jet at the top. The cursory mode of execution of the latter element visually locates it in the background. Apart from the variations in technical execution and surface treatment, there is a play between illusionism and synthetic Cubism in the work. The gas jet, the right-hand side of the guitar and particularly the bottle are depicted in a realistic, if sketchy, fashion and this is one of the earliest examples of the mixture of realism and Cubism. During and after World War I naturalistic features became more common in Picasso's work.

Also unusual in this picture is the gas jet itself. Early on, the Cubists rejected the use of consistent, realistic lighting from visible sources because of its intimate relation to traditional illusionism. Showing a gas jet in this work makes the viewer expect it to be the light source, yet the bottle is modelled so as to indicate that it is lit from somewhere to the right of the gas jet, while the glass has a shadow at its base that points to a source in front of the canvas. Thus, the light neither comes from the gas jet, nor is consistent, so keeping the work true to the whimsical spirit of Cubism.

JUAN GRIS (1887–1927)
Pears and Grapes on a Table

1913. Oil on canvas, 54.5 x 73 cm. Private collection

Executed in October 1913 while Gris was in Céret in the South of France, this work shows a chair and table with an elaborate still life, all seen from above. The vertical view inevitably flattens the space, yet Gris has further reduced most of the objects to two dimensions by depicting them solely in black, as if voids rather than objects. The only item that is naturalistically modelled is that which is the least three-dimensional: the tablecloth, which is draped from the table onto the chair. Gris has also reversed the role of object and shadow: the black pears in the bowl cast shadows to the right that are more substantial than the 'real' objects and they are given a green, slightly modelled form. This play between modes of representation is typical of Picasso and Braque's Cubism and Gris adds to it by the use of the *faux bois* effect on the table. He also ironically acknowledges *papier collé* and collage techniques: the newspapers and chair caning are both painted not stuck on, the latter being executed in a meticulous *trompe l'œil* fashion. Further, the 'shadow knife' is placed as if having cut a gap between the images of the floor and table.

Colour plays an important role in Gris's work as a means of unifying the composition. Here accents of blue create a visual link from top left to bottom right, and the greens and yellows function likewise. The predominant black elements, coupled with the diagonal geometry of the floor pattern, provide a basic armature for the work. In addition, formal links are made between the round forms of the glasses and bowl along the top-right/bottom-left axis. In the same way, the grapes and glass are conceptually connected – the grapes could be drunk in glasses as wine. The physicality of the still life is contrasted with the intellectual and abstract symbolized by the newspaper, an opposition frequently encountered in Cubist still lifes.

ROBERT DELAUNAY (1885–1941)
Sun, Tower, Aeroplane: Simultaneous

1913. Oil on canvas, 132 x 131 cm. Albright Knox Art Gallery, Buffalo, NY

Throughout his career Delaunay continually alternated between abstraction and figuration, though his figurative works often contain abstract elements. On the left-hand side of this painting are abstract colour discs, which stand for the sun; they also formed the basis of the 'Sun and Moon' series of 1912–13. On the right, at the top, is an aeroplane next to the Eiffel Tower. At the bottom is part of the great ferris wheel in the Champs des Mars, another symbol of modernity and a feature of other works of this period. Flight was one of the greatest technological advances of the day and aeroplanes appear in several of Delaunay's works, most prominently in *Homage to Blériot* (Kunstmuseum, Basel). Like other forms of travel and radio, flight suggested the breaking down of geographical barriers and so was an important means of symbolizing simultaneity.

More so than in his other figurative works, Delaunay here succeeded in unifying the pictorial elements so that they could be perceived simultaneously. The structural rhythm of the picture surface prevents the fragmentation of elements found in *The City of Paris* (Plate 16), while the colour contrasts – the brighter colours of the sun and sky and the darker tones of the tower/wheel section – aid this harmony by their interaction. As this work shows, by 1913 Delaunay had moved beyond orthodox Cubism, though it had been invaluable to his development. For him, as for other artists such as Mondrian (see Plate 29), Cubism constituted but one step on the road towards a supposedly purer art form entirely detached from the visible world.

↑

ALEXANDER ARCHIPENKO (1887–1964)
Médrano II (Dancer)

1913. Painted tin, wood, glass and oilcloth, h127 cm. Solomon R Guggenheim Museum, New York, NY

Having left Russia for Paris in 1908, Archipenko quickly got to know the Salon Cubists and first exhibited in 1910 at the Salon des Indépendants, when Cubism was developing as a school. However, his sculpture of this time showed little that was genuinely Cubist, rather he was trying to free himself from the Impressionism of Rodin. The same was true of Duchamp-Villon, the other sculptor in the Salon Cubist group, while in Montmartre Cubism the only sculpture produced by then was Picasso's *Head of a Woman (Fernande)* (Fig. 5) of 1909. By 1912–13 Archipenko had made significant advances, greatly expanding the potential of Cubism in three dimensions. His first multi-media construction was *Médrano I (Juggler)* of 1912–13 (location unknown), which used a similar range of materials as *Médrano II (Dancer)* but was entirely freestanding.

This work attracted much attention at the Salon des Indépendants in 1914. The title derives from the Cirque Médrano, which many of the Cubist artists frequented. The figure is attached to a back panel that provides a backdrop to clarify the forms and to act as a foil for the colours. The central vertical is the main axis for the work, from which all the other forms fan out. Most of the torso is made from folded tin, as is the head, and both elements are edged in red paint. A piece of glass is used for part of the dress and it has a lace pattern painted along the bottom, while the painting on the legs adds naturalistic detail to these otherwise spare forms.

The use of planes to suggest volume is a standard feature of Cubist painting, but Archipenko greatly contributed to its extension into three dimensions. Though Picasso's revolutionary *Guitar* (Fig. 7) is probably contemporary, the range of materials employed makes *Médrano II (Dancer)* closer to certain sculptures by the Futurist Boccioni. During and after World War I Archipenko began to make what he called sculpto-paintings in which painting and sculpture are given equal prominence.

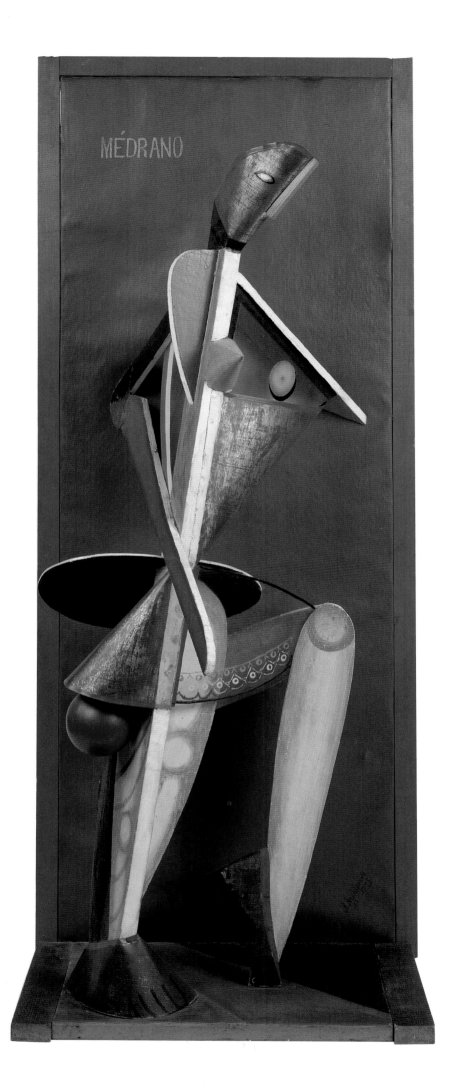

FRANCIS PICABIA (1879–1953)
Udnie (Young American Girl: Dance)

1913. Oil on canvas, 300 x 300 cm. Musée National d'Art Moderne, Centre Georges Pompidou, Paris

Francis Picabia was born in Paris to wealthy Spanish parents and had a somewhat protean nature, assimiliating and as quickly rejecting various artistic movements. In his early years he was a successful Impressionist artist, but about 1908 he took up Symbolism. It was not until 1911 that he encountered Cubism, when he met Duchamp and Apollinaire and became part of the Puteaux group. In 1913 Apollinaire named him as one of the Orphists.

This work was painted after the trip Picabia made to New York in 1913 to see the Armory Show and to set up an art school, and it has a companion piece, *Edtaonisl (Ecclesiastic)* (Art Institute, Chicago). The pair represented the artist's most substantial foray into abstraction up to that time, though Picabia stated that both were 'memories of America'. As indicated by the subtitle, *Udnie* was inspired by a dancer and consequently has a light, dynamic atmosphere. The various geometric and organic forms radiate from the centre, getting larger as they go. The title of the work, like that of its comparison piece, is a word play whose significance is not wholly clear in this case: it may be based on the word 'nudité' or derived from the name 'Undine', the water sprite. In common with other Orphists, Picabia also made a specific connection with music and stated that the two works were 'subtly opposed like musical harmonies'.

Both were exhibited at the Salon d'Automne of 1912, where they received general scorn, except from a few critics like Apollinaire. This public indifference seemed not to worry Picabia much: he was wealthy enough not to have to live from his painting. As with earlier styles, Picabia rapidly moved on from Orphism and by 1915 was producing mechanomorphic pictures using images of machine parts. Soon afterwards he became one of the most iconoclastic of the Dadaists and hence one of Cubism's most implacable enemies.

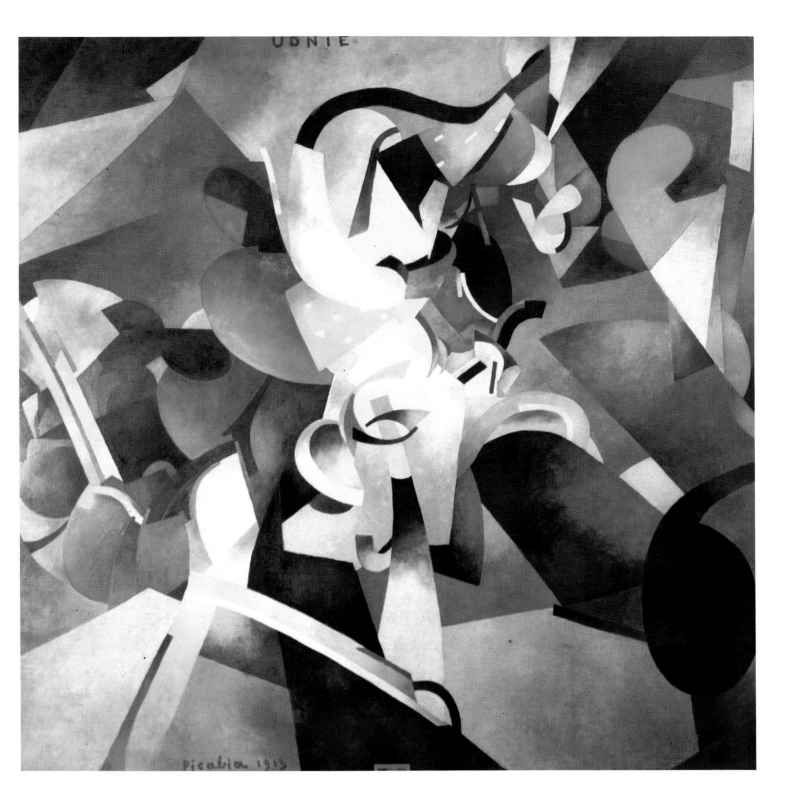

PIET MONDRIAN (1872–1944)
Composition in Grey Blue

1913. Oil on canvas, 79.5 x 63.5 cm. Fundación Colección Thyssen-Bornemisza, Madrid

While in his native Holland, Mondrian produced moody Symbolist landscapes and became interested in Theosophy (a mystical philosophy). In late 1911 he moved to Paris, where he rapidly absorbed Cubism and radically changed both his style and subject-matter. His work quickly assumed the almost illegible Cubist style found in Picasso and Braque's paintings of 1910–11. One of his first attempts at Cubism is *Still Life with Gingerpot II* (Fig. 25), which followed a more naturalistic version of the same subject. In this second picture the objects are reduced to rigid geometrical forms and the composition is dominated by the central, blue ginger jar. To the right of the jar are the lids of other pots, while the foreground is covered by the white of a table-cloth.

Though only a little later, *Composition in Grey Blue* shows the speed with which Mondrian was approaching pure abstraction. In 1912–13 he had painted a number of canvases of trees, the structure of which acted as an armature for the composition. In some, the trees are evident only from the title, as the works themselves are abstract patterns of lines and forms. This painting, though given an abstract title, shows the residue of the tree motif: the composition rises vertically before branching out near the top.

In 1914 Mondrian returned to Holland to visit his sick father, but the outbreak of war prevented his return to Paris until 1919. By this date he was on the brink of his mature, abstract style, known as his De Stijl manner in which the works are structured by rectilinear black lines and coloured using only the primaries red, blue and yellow on a white background.

Fig. 25
Piet Mondrian
Still Life with
Gingerpot II
1912. Oil on canvas,
91.5 x 120 cm.
Gemeentemuseum,
The Hague

LYONEL FEININGER (1871–1956)
The Bridge I

1913. Oil on canvas, 80 x 100 cm. George Washington University Gallery of Art, St Louis, MO

Feininger was born in New York to German parents, but moved to Germany in 1887, returning to America in 1937. His early artistic career was spent as an illustrator and cartoonist. He began to produce paintings only in 1907 and until the early 1910s based them on his own cartoons and caricatures. In 1906–7 he visited Paris and met Delaunay, and he revisited the city in 1911, at which time he encountered Cubism. *The Bridge I* is one of a series of works on the subject executed at various times in the 1910s. Based on a bridge in Ober-Weimar, it displays a more confident and complex handling of form and space than his slightly earlier paintings. The arches of the bridge are echoed in both the forms of the trees and the planes of the sky, while the colours – mostly shades of green – also help to unify the composition, making the whole somewhat reminiscent of Gothic vaulting. The concentration on an architectural feature is typical of many of Feininger's mature works, in which tiny figures are dwarfed by huge, haunting buildings. *Yellow Street* (Fig. 26) is characteristic of his lighter works, in which each of the figures is given exaggerated features as in a caricature. The composition is constructed from a series of interlocking, curved facets, which cement the separate elements.

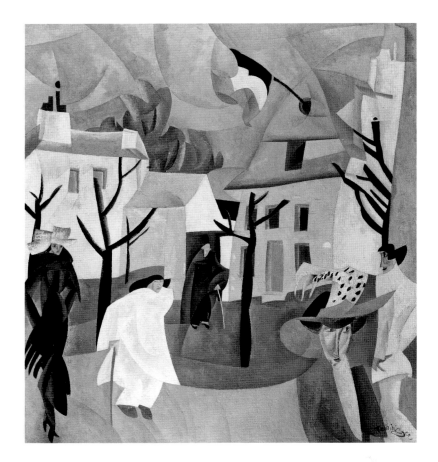

Fig. 26
LYONEL FEININGER
Yellow Street
1917. Oil on canvas,
86 x 95.5 cm.
Museum of Fine Arts,
Montreal

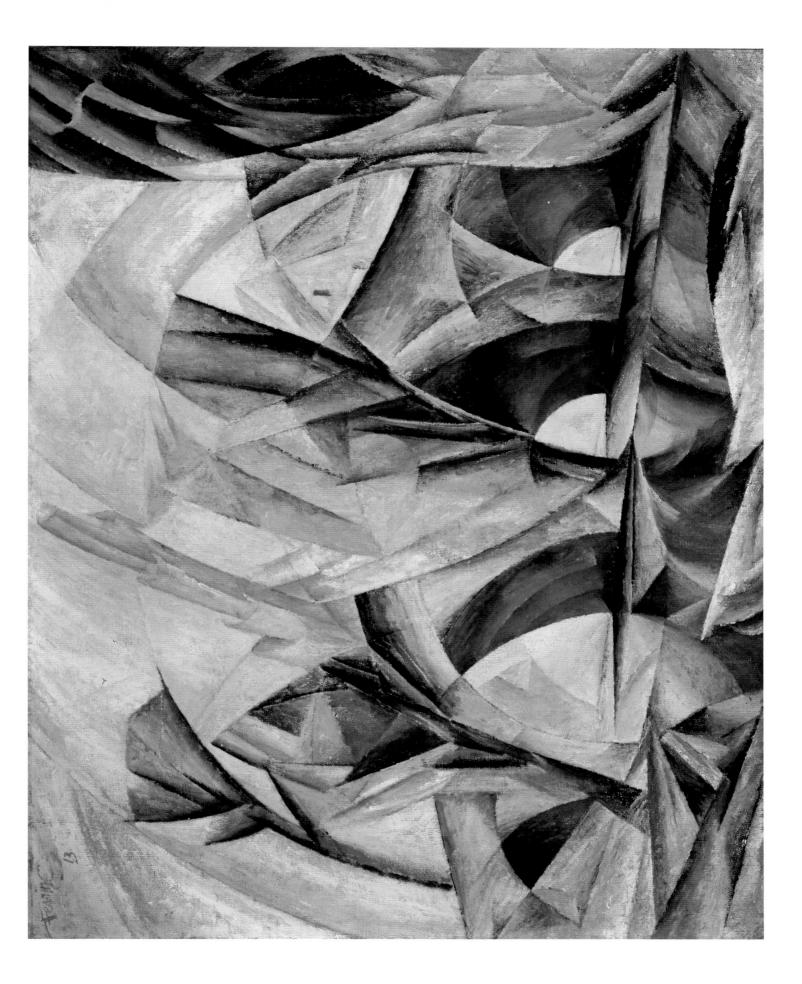

GEORGES BRAQUE (1882–1963)
Violin and Pipe: *Le Quotidien*

1913–14. Chalk, charcoal and pasted paper on paper, 74 x 106 cm. Musée National d'Art Moderne, Centre Georges Pompidou, Paris

This complex *papier collé* is named after the fragment of the newspaper *Le Quotidien du Midi* it incorporates, though it also includes a piece of *Le Journal*. The still life is set on a table whose extent is marked by the oval outline of charcoal. On the left is a newspaper represented cursorily in charcoal as an outline with lines of text, while the extract from *Le Quotidien du Midi* represents another newspaper. The second piece of newspaper stands for the table-top, and newspaper plays yet another function in the cut-out pipe, the bowl of which is highlighted in charcoal. The violin is made in two parts: the black silhouette to the left with a sound hole in white chalk, and the piece of *faux bois* wallpaper whose illusionistic texture is used to indicate that of the real instrument. The scroll of the violin is executed in charcoal and appears partially twisted, while a piece of wallpaper with a decorative frieze indicates the neck of the violin. To the left of the drawn part of the violin neck Braque has added a shadow to suggest volume, as with some of the other elements.

As well as reflecting the artists' everyday lives, the prevalent use of newspaper in the *papiers collés* symbolizes the fact that there is the same gap between art and reality as there is between a newspaper report and real events. Inevitably, but also deliberately and selectively, the pieces sometimes refer to topical events: here the large fragment of newspaper at the top, upside down, includes a headline about the financial state of the army at a time when France was close to war.

Later in 1914, Braque used this *papier collé* as the basis for a painting, showing – as with *Fruit Dish, Ace of Clubs*, (Plate 22) – the close relationship that existed between the two media in his *œuvre*.

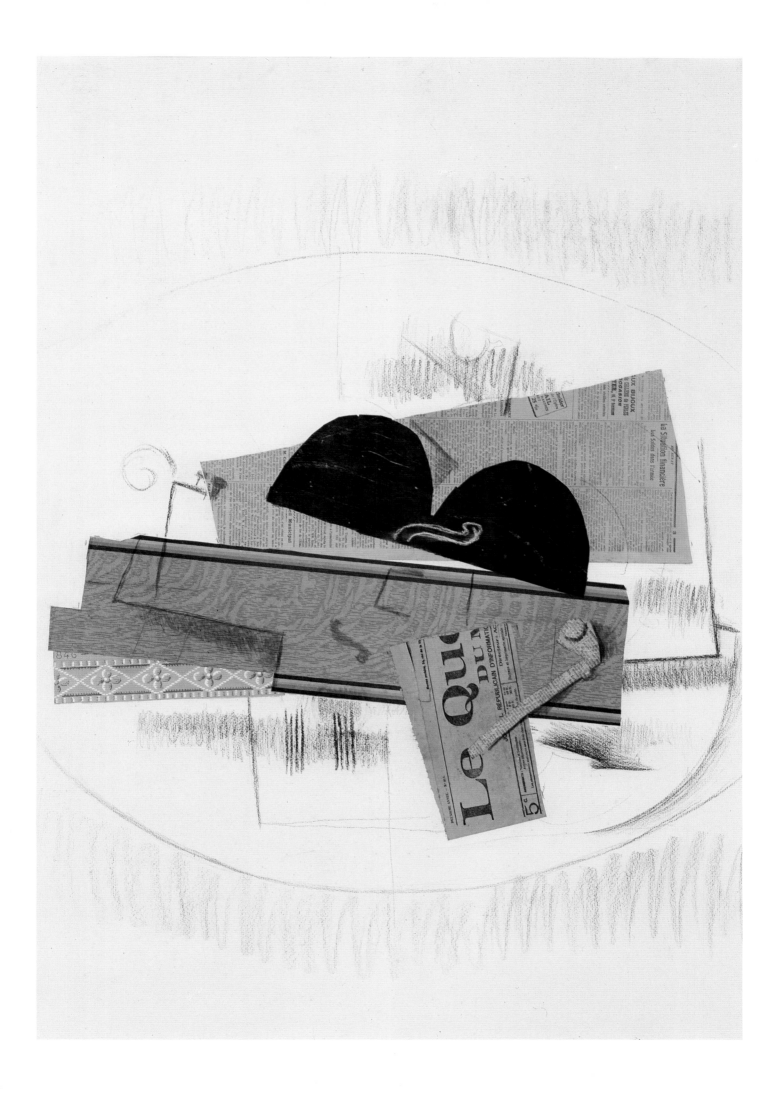

PABLO PICASSO (1881–1973)
Still Life Construction

1914. Painted wood with upholstery fringe, h25.5 cm. Tate Gallery, London

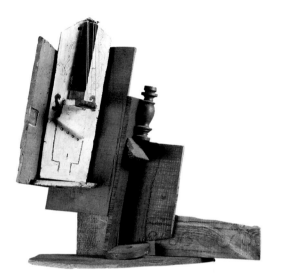

Fig. 27
PABLO PICASSO
Violin and Bottle
on a Table
1915. Wood, string, nails
and charcoal, h42 cm.
Musée Picasso, Paris

One of the key motivations behind Cubism was the search for alternative means of representing solid objects on a flat surface. It is perhaps because this specific issue does not arise in three-dimensions that sculpture received so little attention in the early development of Cubism. However, there is a different but related problem with sculpture: how can one solid object represent another? The constructions from early 1914 – all essentially relief works designed to be wall-mounted – show Picasso radically challenging the traditional solutions to this question.

The two most interesting features of this construction are the glass and the use of the upholstery fringe. The knife, two slices of sausage and slab of pâté are created naturalistically by carving and painting. But Picasso's attempts to represent the glass in a naturalistic way are limited if only by the opacity of the wood, yet he deliberately undermines the illusion further still. The main body of the glass is made from a single piece of wood that curves inwards on the left and has incised fluting, so seeming to represent the outside of the object. However, the attachment of the three other pieces of wood confusingly suggests that the enclosed volume is on the viewer's side. Such tricks, so typical of two-dimensional Cubism, here make the space as much a material as the wood. Extending from the left of the glass is a dado rail that economically indicates the background, while around the edge of the abbreviated table that holds the still life is a real upholstery fringe, standing for the draped part of the table-cloth. The use of real material relates it to Picasso's earlier *Still Life with Chair Caning* (Fig. 6) of 1912 but whereas the printed oilcloth stands for what it is – a table-cloth – here it does not: one would not expect an upholstery fringe around a table. Thus, the identity of the fringe has been manipulated in a manner typical of synthetic Cubism.

The very use of constructions posed a radical challenge to traditional sculpture, suggesting, as in *papier collé*, that anything can be made into art and that anything could stand for anything else. The inelegant, crude style of this unappetizing construction also subverts expectations of the artist's technical ability and invites a disturbing comparison with the lush, highly finished still lifes of food by seventeenth-century Dutch artists. In the slightly later construction *Violin and Bottle on a Table* (Fig. 27), an even greater spatial complexity and reduction of the forms is evident.

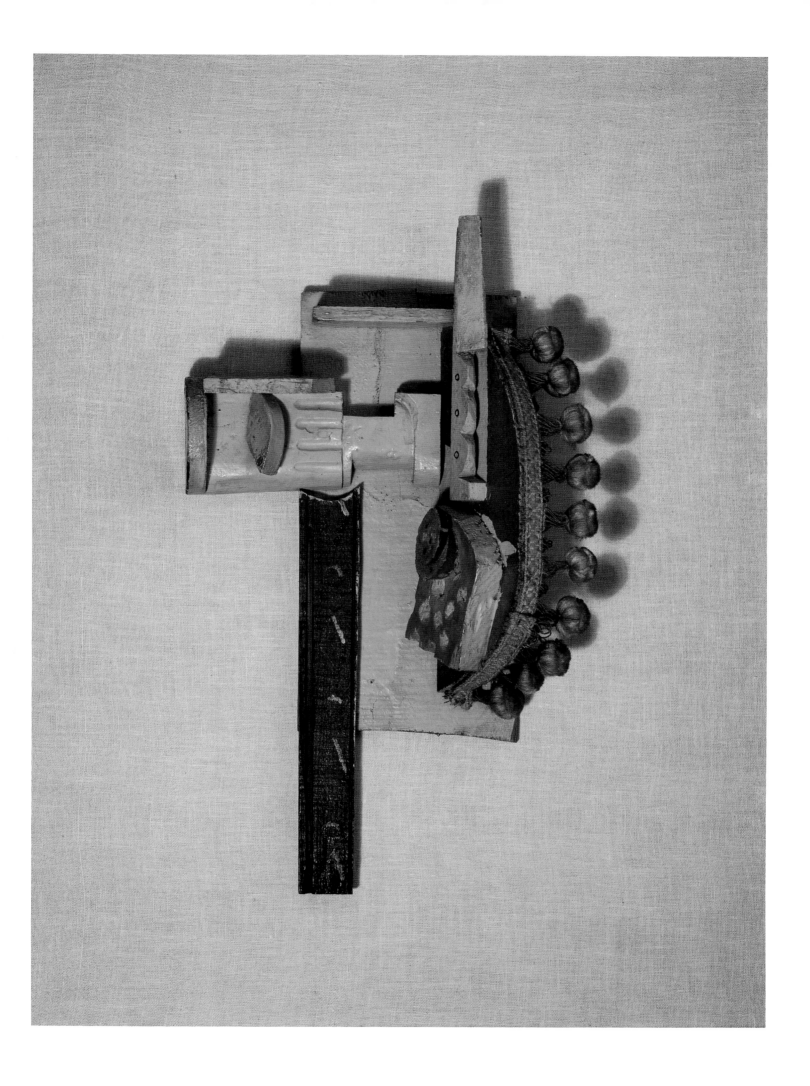

PABLO PICASSO (1881–1973)
Green Still Life

1914. Oil on canvas, 60 x 79.5 cm. Museum of Modern Art, New York, NY

Fig. 28
GEORGES BRAQUE
Bottle of Rum
1914. Oil on canvas,
46 x 55 cm.
Private collection

From June to November 1914 Picasso was in Avignon, where in August he saw off Braque following his mobilization. Curiously, considering the dire turn of political events, but perhaps in reaction to them, Picasso's work from this period has an extraordinary exuberance and vitality, as is evident here. The saturated colour scheme of this still life recalls Matisse's *Red Studio* of 1911 (Museum of Modern Art, New York), and both unites and flattens the composition. To the left of the central bottle and glass are a pear and a bunch of grapes, and to the right a newspaper, fruit bowl and tobacco packet. The Pointillist decoration of certain areas is typical of Picasso's work of this period and adds to the baroque sumptuousness of the image. It even extends to the letters 'JOU' from the newspaper title *Le Journal*: these are commonly found in Montmartre still lifes to suggest the word 'jouer', to play.

There are several anomalies in the treatment of the objects: the bunch of grapes is given an angular stalk and a geometric right-hand side, creating a visual pun with the form of the bottle, while the glass is given a red, incandescent radiance around its left-hand side. Most peculiar is the fruit bowl on the left, which seems to be in flight; a shower of yellow dots spray from its left edge while behind it, following the extension of its contours, an impasted oval extends as far as the pear. From the side of this, concentric lines in yellow and red spread outwards across the bottle and the table; others to the bottom have been overpainted, but are still visible. This device is also evident in the subsidiary forms by the glass, pear and grapes and is characteristic of the way Picasso blended objects into their surroundings in his works of this period. The lines around the bowl are reminiscent of those used by the Futurists to indicate force and energy.

The more sensuous, decorative trend evident in this form of Cubism is also evident in Braque's work of this period. In his slightly earlier *Bottle of Rum* (Fig. 28) the composition is dominated by the mass of Pointillist colouring. Such techniques continued into the post-war period and were taken up by other artists.

FRANZ MARC (1880–1916)
Deer in a Forest II

1913–14. Oil on canvas, 110.5 x 100.5 cm. Staatliche Kunsthalle, Karlsruhe

Animals formed Marc's main subject and were used by him to express his fervently spiritual understanding of the world. He felt people had a 'lack of piety' and that animals had, by contrast, a greater purity. He once stated that 'animals with their virginal sense of life awakened all that is good in me', and this fascination with nature shows the profound influence on him of German Romanticism. Though Marc's subject-matter remained constant, his style gradually changed, mainly in response to French art. Initially he was affected by the expressive approach of Vincent van Gogh (1853–90) and the Fauves (he visited Paris in 1907), but in 1912 he became interested in the work of Delaunay, whom he visited in Paris that year, accompanied by his friend August Macke (1887–1914). Delaunay's personal brand of Cubism appealed to Marc, as it did to Macke and Paul Klee (1879–1940), because of its emphasis on colour. For Marc, and his Russian friend Kandinsky, colours were used in a work to create symbolic meaning: yellow denoted femininity and sensuality, blue masculinity and the spiritual, and red the terrestrial and material.

This painting is one of Marc's last (he was called up in 1914 and killed at Verdun in 1916) and develops a subject he had explored in a painting of 1913. It reflects his response to Cubism through the geometrical armature that supports the composition, emphasized in the black lines, and it also shows a use of purely abstract elements (Marc produced some wholly abstract works in 1914). Its employment of a Cubist vocabulary for highly emotive ends was a hallmark of the movement's adoption in Germany.

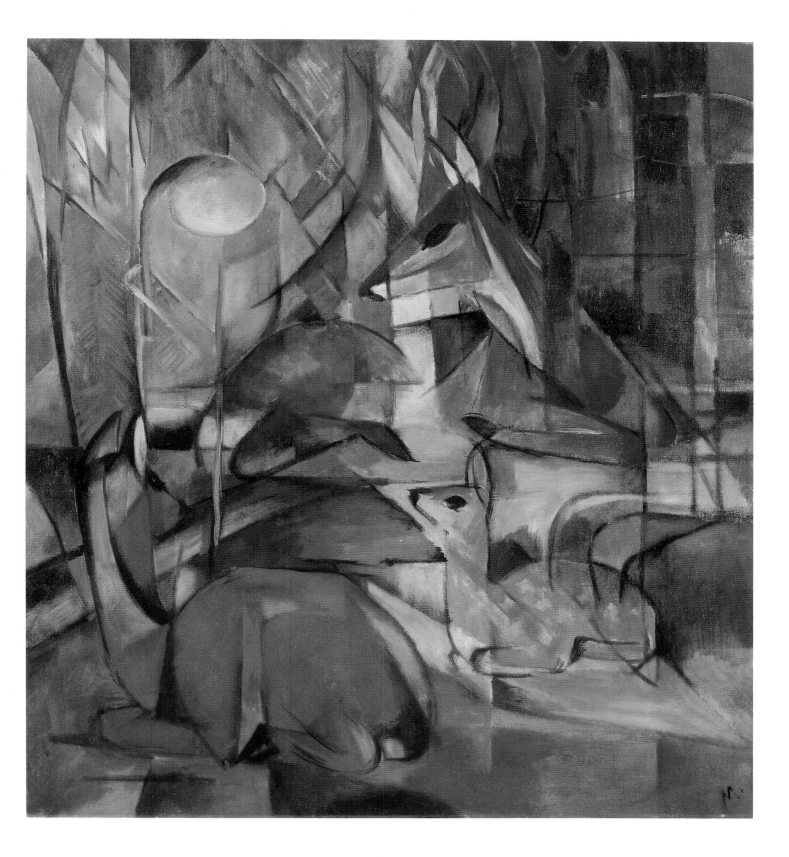

35 JUAN GRIS (1887–1927)
Still Life before an Open Window:
Place Ravignan

1915. Oil on canvas, 116 x 89 cm. Museum of Art, Philadelphia, PA

In 1915 Gris began to reassess his art and wrote to Kahnweiler that he was aiming for a greater unity in his work, while trying to move away from the 'inventories of objects' he saw in his preceding pictures. He abandoned *papier collé* and collage, which he had used in 1913–14, and developed a more generalized, schematic depiction of objects, as is evident in this painting. This important canvas breaks new ground in Cubism by juxtaposing distant outdoor space with a domestic interior, something Picasso and Braque had not tried because of their determination to remove any traces of scientific perspective. Here Gris creates depth through the traditional devices of spatial recession and the use of paler tones for the background. In addition, the overlapping sequences of flat planes in the still life bring it nearer the picture surface and hence into the foreground, while the townscape is flattened by its predominantly uniform colour. The colour blue links together the disparate elements of the composition; the blue of the empty street echoes that of the still life and its surround, and also gives the whole work a haunting air of mystery.

On the table to the left is a bottle of wine marked 'MEDOC', which is depicted as if traced out in space and so elongated; a similar device is used for the glass at the front, which has straight parallel sides between the curved ends. The label on the bottle is also distorted as, to a greater degree, is the newspaper heading 'LE JOURNAL'. It is as if each plane acts like a lens between the object and the viewer, emphasizing the barrier between art and reality. On the left foreground are two abstract fragments painted in a Pointillist manner, which, as in Picasso's work of the period, further illustrate Gris's attempt to expand his expressive range.

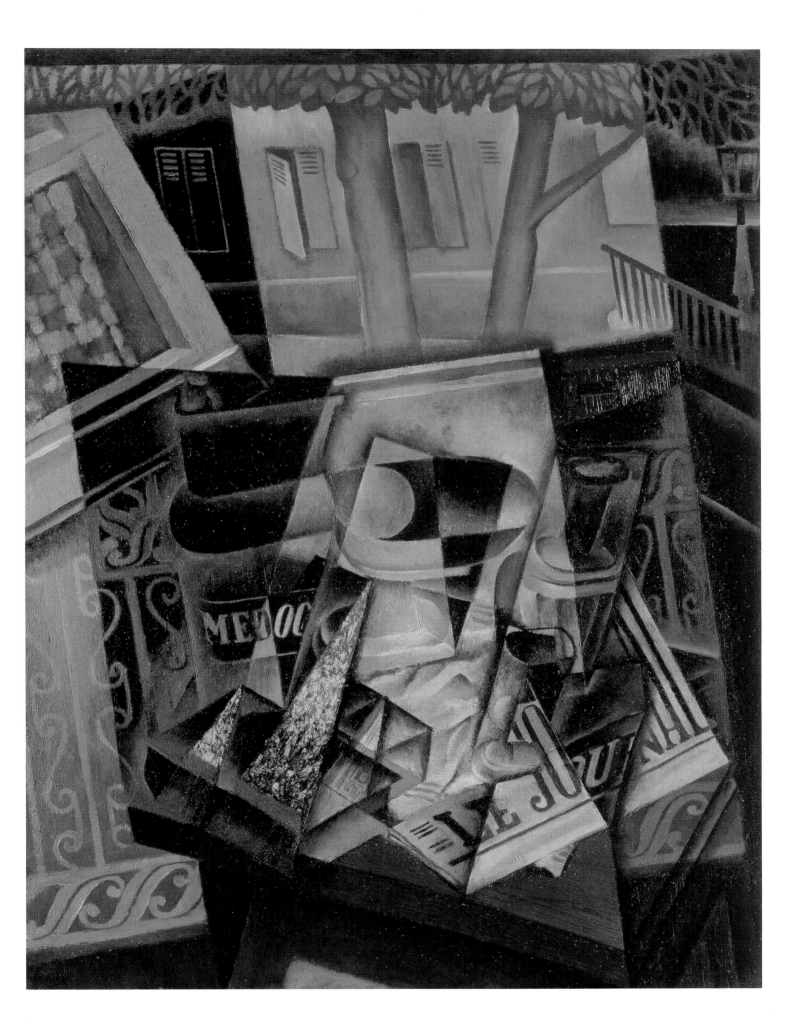

EMIL FILLA (1882–1953)
Tray with Bunch of Grapes

1915. Watercolour and oil with sand on plywood, 39.5 x 30 cm. Národní Galerie, Prague

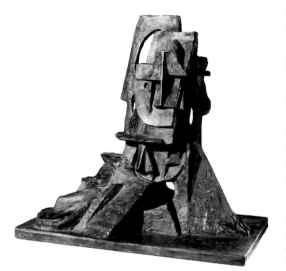

Fig. 29
OTTO GUTFREUND
Man's Head
1913. Bronze, h60cm.
Národní Galerie, Prague

Czech Cubism began to emerge in 1910 and came to be centred on the Group of Fine Artists, set up in 1911. The group included the painters Filla, Josef Čapek (1887–1945) and Antonín Procházka (1882–1945) and the sculptor Gutfreund, though there were others working in a Cubist idiom also, such as the painter Bohumil Kubišta (1884–1918). As well as painting and sculpture, Cubism affected design, making Prague the most important centre for the movement outside Paris before World War I. Many artists had been influenced by Expressionism from Germany and Austria and by the work of Edvard Munch (1863–1944), and this continued to be a force in Czech Cubism. Thus, in addition to the quiet scenes characteristic of French Cubism, there were paintings of extreme subjects, such as those by Kubista of murder and hanging, and this hybrid development is often called Cubo-Expressionism.

Having earlier produced Expressionist works under the influence of Munch, Filla rejected this emotive approach when he took up Cubism, so becoming the closest of the Czechs to French Cubism. Painted while he was in the Netherlands during World War I, this work shows his familiarity with recent trends in French art. The use of large flat planes, Pointillist decoration and the sand mixed in the paint are hallmarks of synthetic Cubism, and Filla also added a naturalistic element in the bunch of grapes. The choice of a still life confirms his rejection of Expressionism, while the careful execution and the central, stabilizing V-shape that reaches to the bottom of the work add to the calm, static air of the composition.

Gutfreund, who had studied under the sculptor Antoine Bourdelle (1861–1929) in Paris from 1909 to 1910, was the most revolutionary of the Czech Cubists and, after Picasso, the first artist to experiment with Cubist sculpture. Immediately following his return from Paris he developed a personal blend of Cubo-Expressionism, but his works of 1912–13 demonstrate a more thorough assimilation of French Cubism, as shown in *Man's Head* (Fig. 29). This sculpture is built up of planar elements with a great economy of form, and space has an important constructive role; it is used for example, on the top left plane to suggest the side of the man's head.

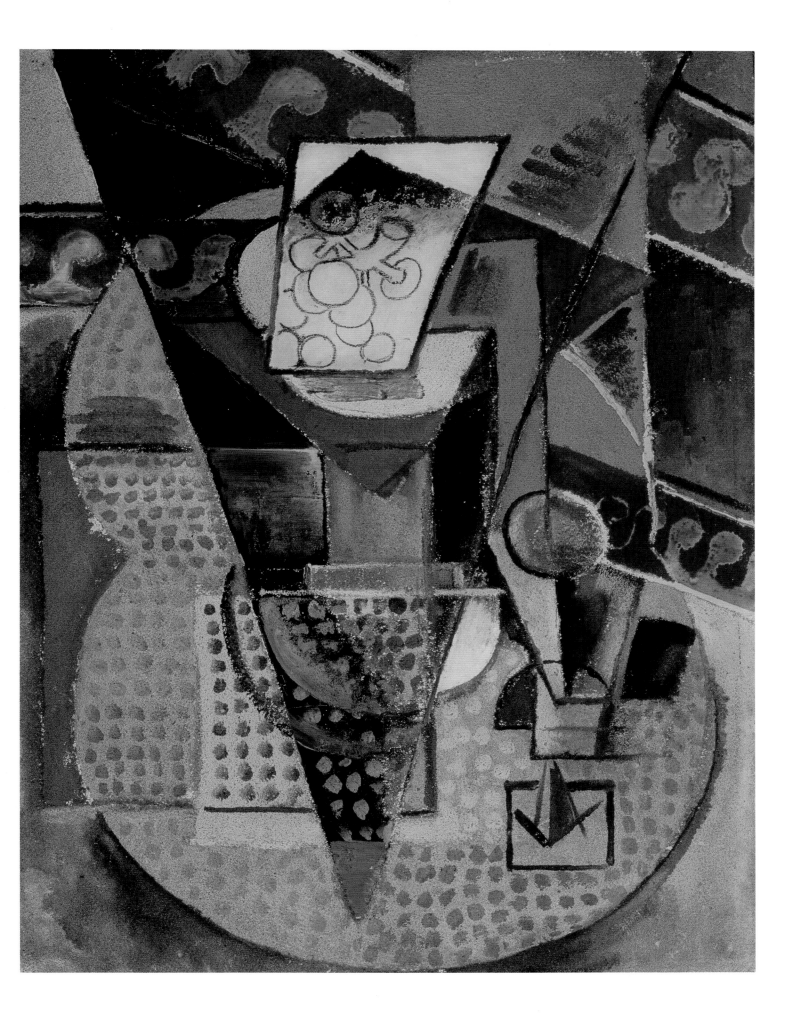

EDWARD WADSWORTH (1889–1949)
Abstract Composition

1915. Ink and gouache on paper, 42 x 34.5 cm. Tate Gallery, London

Fig. 30
WYNDHAM LEWIS
The Crowd
1914–15. Oil on canvas,
200.5 x 153.5 cm.
Tate Gallery, London

Wadsworth was one of the 11 signatories of Wyndham Lewis's Vorticist manifesto, which appeared in the first issue of the journal *Blast* in July 1914. In the editorial Lewis claimed 'WE ONLY WANT THE WORLD TO LIVE and to feel its crude energy flowing through us.' Energy, modernity and dynamism were the ideals of Vorticism and the manifesto especially attacked England and its culture, but also France because of its 'pig plagiarism, BELLY, SLIPPERS, POODLE TEMPER, BAD MUSIC' and 'SENTIMENTAL GALLIC GUSH'. The additional insults made against Cubism and Futurism were primarily a political means of retaining artistic autonomy, since both, in fact, deeply influenced the English movement.

The vortex was to be the key to Vorticist art and was described thus by Lewis: 'At the heart of the whirlpool is a great silent place where all the energy is concentrated.' Hence, in the lower left of this picture by Wadsworth the abstract forms are compressed into a small kernel from which they spread out across the picture surface. As they expand away from the blue and green centre, the colours become less vivid, diluting into a series of beige and brown elements. In contrast to works by other Vorticists, this painting is comparatively quiet and balanced. More striking is Lewis's huge *The Crowd* (Fig. 30), executed in glowing tones of red and yellow. Here, tiny abstracted figures are crowded together in small groups amid vast geometric buildings, producing a disturbing vision of the city and reflecting Lewis's comment in *Blast* that 'Dehumanization is the chief diagnostic of the Modern World.'

Though he remained aloof from the official movement, Bomberg was also influenced by Vorticism, as well as Cubism and Futurism. This is seen, for example, in *Ju-Jitsu* (Fig. 31), in which highly abstracted and fragmented figures are merged into a rigid and obtrusive geometrical grid.

Fig. 31
DAVID BOMBERG
Ju-Jitsu
*c*1913. Oil on canvas,
62 x 62 cm.
Tate Gallery, London

MAX WEBER (1881–1961)
Chinese Restaurant

1915. Oil on canvas, 101.5 x 122 cm. Whitney Museum of Art, New York, NY

Fig. 32
JOHN MARIN
Woolworth Building
1912. Watercolour on
paper, 48 x 38.5 cm.
National Gallery of Art,
Washington DC

Born in Russia, Weber moved to America at the age of ten and from late 1905 to late 1908 lived in Paris. There he met Picasso and also studied under Matisse, but he became especially friendly with the elderly Rousseau who came to think of Weber as almost a son. In 1910 Weber's essay 'The Fourth Dimension from a Plastic Point of View' appeared in the journal *Camera Work*. This was the first published statement of the relation between the fourth dimension and art and it influenced Apollinaire, among others. Weber defined the fourth dimension as 'the consciousness of a great and overwhelming sense of space magnitude in all directions at one time...It is real and can be perceived and felt. It exists outside and in the presence of objects.'

Despite Weber's evident intellectual sympathy, the effects of Cubism were not apparent on his art until after his return to New York. Certain of his pictures of 1910–11 include primitive figures similar to those in *Les Demoiselles d'Avignon* (Plate 3) but his real engagement with the movement occurred between 1913 and 1917, when as with many artists outside France, its influence was mixed with that of Futurism. In *Chinese Restaurant* he aimed to capture a diverse range of sensations in a single image, as he explained: 'On entering a Chinese restaurant from the darkness of the night outside, a maze and blaze of light seemed to split into fragments the interior and its contents, the human and inanimate. For the time being the static became transient and fugitive...To express this kaleidoscopic means had to be chosen.' Amid the assemblage of shattered elements are various recognizable features: the tiles on the floor, the eaves of a pagoda and the heads, cinematically rendered, of the waiters and diners. The bright colours and dynamism of the composition suggest the life and vitality of the scene, the interleaving of fractured planes showing a clear debt to Cubism. Among the other Americans to be influenced by Cubism was Marin who was a friend of Weber's in Paris. His watercolour of the *Woolworth Building* (Fig. 32) employs a limited, but Cubist, fragmentation of forms to create an unstable, dynamic image reminiscent of Delaunay's 'Eiffel Tower' works.

JUAN GRIS (1887–1927)
Portrait of Josette Gris

1916. Oil on canvas, 116 x 73 cm. Museo Nacional del Prado, Madrid

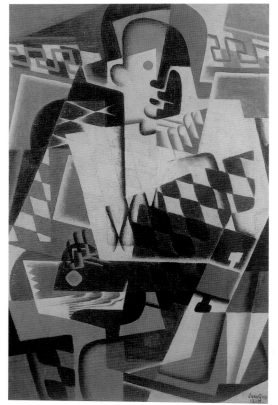

Fig. 33
JUAN GRIS
Harlequin with Guitar
1917. Oil on canvas,
100 x 65 cm.
Private collection

Though never actually married, Gris always referred to Josette (née Charlotte Herpin) as his wife and the two lived together from early 1914 until the artist's death. This work is related to Gris's slightly earlier *Woman with a Mandolin after Corot* of 1916 (Kunstmuseum, Basel), from which the pose and dignified expression are taken. Its indirect connection with one of the great French artists (Corot's reputation was especially high then) reflects the more general interest in the past embodied in the 'return to order'. The painting perfectly illustrates Gris's techniques for unifying an image. There is, for example, the rhythm created by the curved black forms of Josette's body and also the blending of colours to integrate foreground and background, a link enhanced by the shadow on the back wall. As in other works, though to a lesser extent, Gris juxtaposed the naturalistic and the abstract, as in the treatment of the hands and head. The presence of the rectilinear panelling in the background highlights the curvaceous lines of Josette's body, while the sober colours and her calm, majestic pose reflect one of the ways in which women were perceived at the time. Partly due to the national war effort, women were presented as the 'guardians of the hearth' and the support of the country while the men were away fighting.

Gris's drawing of a Harlequin of 1916 (Musée National d'Art Moderne, Centre Georges Pompidou, Paris) after Cézanne represented another response to the 'recall to order' and was followed by a long series of paintings on this traditional French subject, the first of which was the complex *Harlequin with Guitar* (Fig. 33).

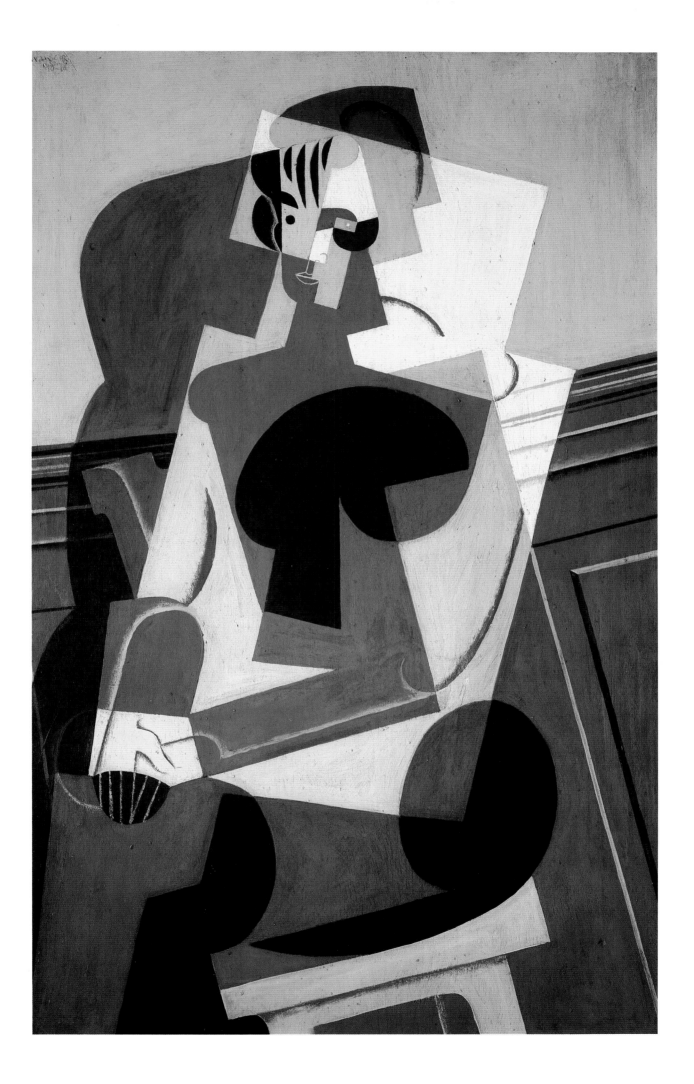

FERNAND LÉGER (1881–1955)
The Card Players

1917. Oil on canvas, 129 x 193 cm. Rijksmuseum Kröller-Müller, Otterlo

Léger was called up in 1914 and, after being gassed in the spring of 1917, was sent to recuperate in Paris and then demobilized at the end of the year. While active as a soldier, he managed to produce a number of sketches of his fellow men and of the battle areas. The Futurists had glorified war as the 'only purifier of the world', and they idolized its violence and associated machinery. Though not romanticized in the same way, war also captured Léger's imagination and prompted him to take up a more realistic, if still Cubist-inspired, style. As he later commented of this period: 'Gun barrels, the sun that shines on them, the nakedness of things themselves – that is what shaped me.'

This picture was executed during Léger's period of convalescence in Paris and is his most significant treatment of a war subject. The soldiers are depicted as if machines and are carefully modelled in gun metal grey. This characterization of man as a machine was suggested to the artist by his exposure to military organization and discipline, but also by the earlier ideas of the poet Henri-Martin Barzun and the Futurists. Hence, though the geometric composition and dislocation of the figures are typically Cubist, they are particularly well suited to the subject-matter here. On the far left of the painting are two NCOs, wearing medals and kepis. On the right is an ordinary soldier, a *poilu*, who looks on as the others play cards, the smoke from his pipe appearing as a billowing sequence of geoemtrical forms. Idly passing their time, the figures have a subdued, lifeless mood that is emphasized by the precise execution and cool blue-grey colours of their constituent forms. The scene depicted was doubtless a common one in the army, but it also alludes to paintings by Cézanne of the same subject. In addition, the element of chance in card games suggests the precarious existence of the soldier's life.

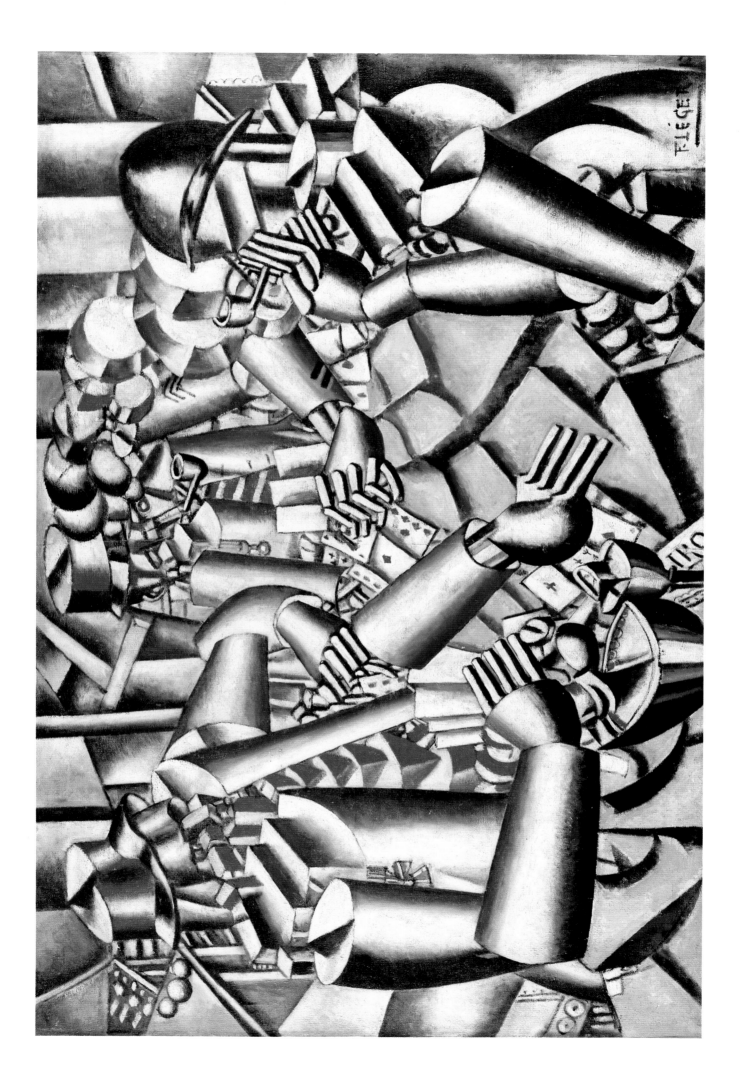

FERNAND LÉGER (1881–1955)
The City

1919. Oil on canvas, 236.5 x 305.5 cm. Museum of Art, Philadelphia, PA

This vast canvas is the culmination of a large series of works on the subject painted by Léger in 1919, this one being described by him as an 'artistic revolution'. For the artist and his poet friend Cendrars, the city had great significance as the centre of modern life, as the place where experience is most intense and the new most apparent. In his early works Delaunay represented the city, specifically Paris, for the same reasons.

Posters were seen as particularly characteristic of the modern city, and in this work Léger adopted their large scale as well as depicting one on the right. The extreme flatness, created by the unmodelled planes of pure colour, is emphasized by the inclusion of precisely delineated letters. Among the recognizable elements are fragments of steel girder and the stylized clouds of smoke rising vertically in the centre. Beneath the latter are two figures, executed in Léger's typical tubular style, on a flight of stairs. On the left, by the letter 'R', is one half of a colour target disc, an element that recurs in other of Léger's paintings of this period. As well as referring to the sun discs of Delaunay, this indicates the distinction Léger still made between representational features and those 'pure' elements that serve solely abstract pictorial ends. Other elements are similarly non-representational. The image moves abrubtly from one section to another in a cinematic fashion, but without any logical connection, a further reflection of the Simultanist perception of the city as a generator and focus of disparate experiences.

The identity of the city itself is not made specific, and unlike Delaunay, Léger does not, for example, include any landmarks such as the Eiffel Tower. Further, though the various elements are bound together pictorially, there is no unifying narrative or meaning: the letters spell nothing, the smoke emerges from nowhere, the figures seem aimless. This disconcerting atmosphere is enhanced by the half concealed, cut-out figures – one on the poster on the right, another on the left – that appear suddenly from behind objects. This dehumanized atmosphere captures another aspect of the machine aesthetic seen emerging in *The Card Players* (Plate 40)

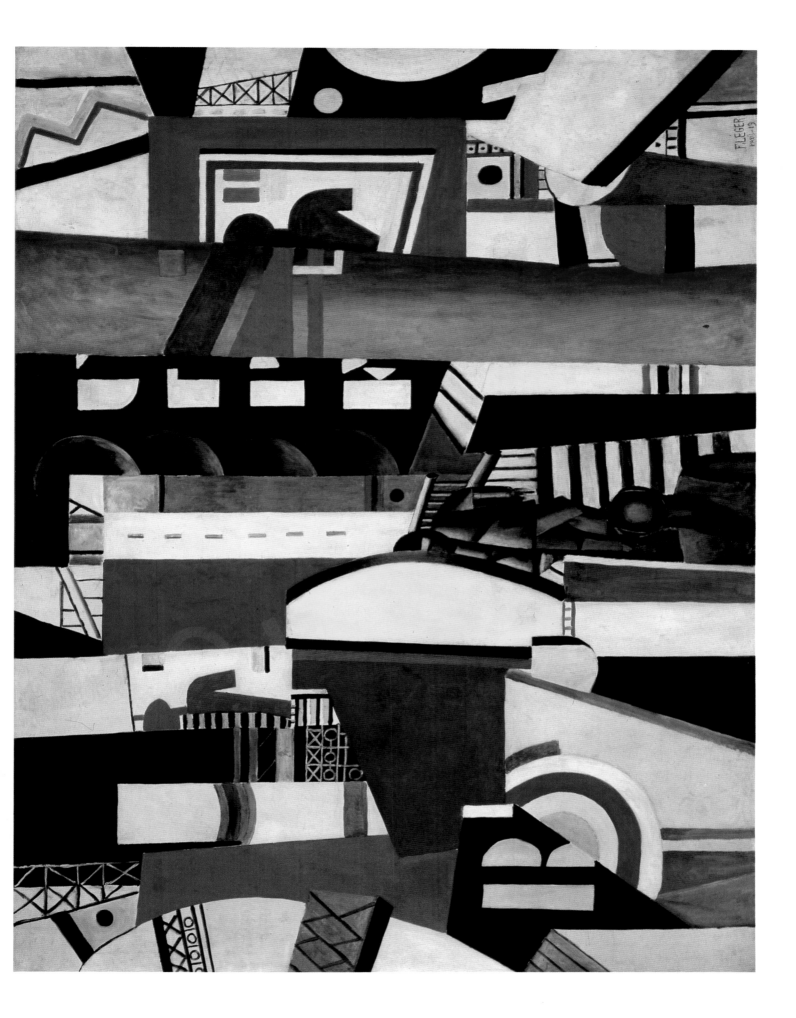

HENRI LAURENS (1885–1954)
Head of a Boxer

1920. Stone, h31 cm. Galerie Louise Leiris, Paris

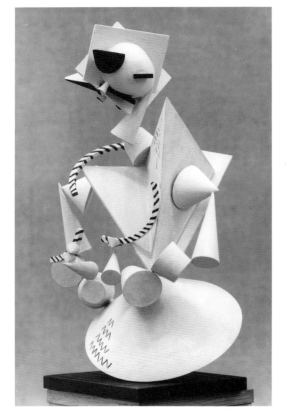

Fig. 34
HENRI LAURENS
The Clown
1915. Painted wood,
h60 cm.
Moderna Museet,
Stockholm

Laurens trained as an ornamental sculptor, although he also took lessons from an academic sculptor, and his early work was influenced by Rodin. In 1911 he met Braque and the following year began to experiment with Cubism. Due to osteo-tuberculosis he had a leg amputated in 1909 and was therefore exempted from mobilization in 1914, the first year from which any of his Cubist sculpture survives. These early works are mostly polychromed constructions such as *The Clown* (Fig. 34), which consists of a dynamic jumble of geometric elements, the light, playful manner perfectly suiting the subject. During the war Laurens continued to develop his Cubist style and also met both Picasso and Gris. He produced *papiers collés* and Cubist drawings and, under the influence of Picasso, still-life constructions using sheet metal and wood. Though formally indebted to Picasso's work these latter were more carefully constructed and finished.

Soon after the war Laurens began to work predominantly in stone and terracotta, which he sometimes painted. Sculptures in bronze and low reliefs soon followed, the reliefs allowing a more direct transcription of the Cubist vocabulary. The boxer theme first emerged in his work in 1919 and resulted in both heads, like this, and half-length figures. This work is typical of Laurens's Cubist sculpture, showing how he manipulated the expected relations between space and solid and also mixed Cubism with naturalism. The only feature that might identify the head as that of a boxer is the rather flat, perhaps broken nose. On the right-hand side the face is carved in undulating forms, which give it a ripple of shadow that enhances the sense of volume through contrast with the bright, flat left-hand side. The left side of the head is carved deeper than the neck below, while on the right the relationship between solid and space is as expected. The ear is given volume between the stepped planes of the hair and neck, while the hair is seen in depth and cross section at the top, but incised naturalistically along the forehead. By the beginning of the 1930s Laurens had largely abandoned Cubism in favour of a more massive, rounded style in which he worked mainly in bronze.

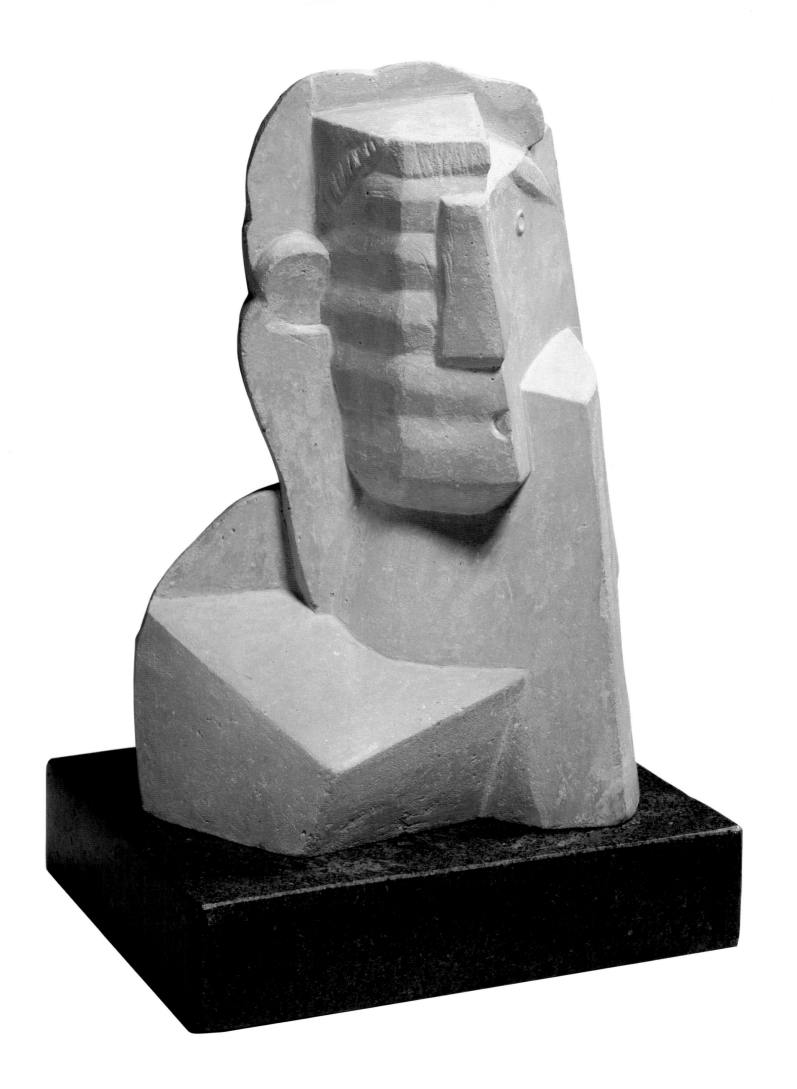

PABLO PICASSO (1881–1973)
Three Musicians

1921. Oil on canvas, 203 x 189 cm. Museum of Art, Philadephia, PA

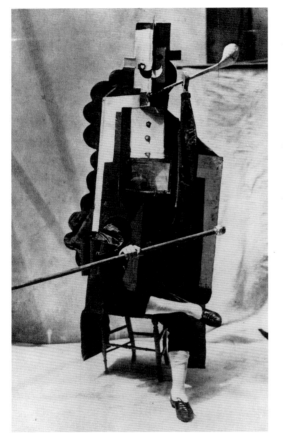

Fig. 35
PABLO PICASSO
Manager in Evening
Dress
1917. Photograph of a
costume from the ballet
Parade

In 1917 Picasso created the sets and costumes for the ballet *Parade*, performed by Sergei Diaghilev's Ballets Russes with music by Erik Satie and scenario by Jean Cocteau (Fig. 35). The production was badly received, the Cubist elements in it being decried as 'Boche' by the audience at its Paris premier. Nevertheless, this experience with theatre prompted Picasso to pursue the *commedia dell'arte* themes that had been so prominent in his pre-Cubist paintings and in his more recent works, such as *Harlequin* (Fig. 12). This resulted in a number of images of pierrots and harlequins, and he developed this subject-matter further in the décor and costumes for the ballet *Pulcinella* (1920), again for the Ballets Russes, but with music by Igor Stravinsky and a specific *commedia dell'arte* theme.

It is against this background that Picasso painted the two versions of the *Three Musicians*, (the other is in the Museum of Modern Art in New York). They represent the full culmination of his post-war Cubism, being described by the critic Maurice Raynal as 'magnificent shop windows of Cubist inventions and discoveries'. Both were painted at Fontainebleau, where Picasso had gone with his wife, the dancer Olga Koklova (from the Ballets Russes) and their son Paolo.

The sharp, interlocking forms of this picture perfectly exemplify the characteristics of crystal Cubism. On the left is a harlequin playing a violin, in the middle a pierrot playing a clarinet or recorder and on the right a monk with an accordion, his other hand holding a glove. Each has a rather menacing, mask-like face, which reflects the renewed interest Picasso had taken in African art immediately before the war. The severe planar construction derives from the techniques of *papier collé*: the hand and bow of the harlequin are painted in an area of white as if on paper. Picasso plays the usual tricks with forms, creating a profile in the pierrot's clarinet and another profile to the right of the monk's elbow, echoing the moulding of the wall nearby. He also treats similar elements in a variety of ways, as in the depiction of the hands. Formal rhythms are set up between, for example, the notes on the music and the keys of the accordion.

The subject of the *commedia dell'arte* suggests the contrivance and disguise of art, but a more specific reading of this work has been suggested by Theodore Reff. He sees the harlequin as representing Picasso, the pierrot Apollinaire (who died in 1918) and the monk Max Jacob (who had converted to Roman Catholicism and retreated to the country). The melancholy aura of the picture thus expresses Picasso's sorrow at the loss of these friends and the passing of his carefree pre-war years.

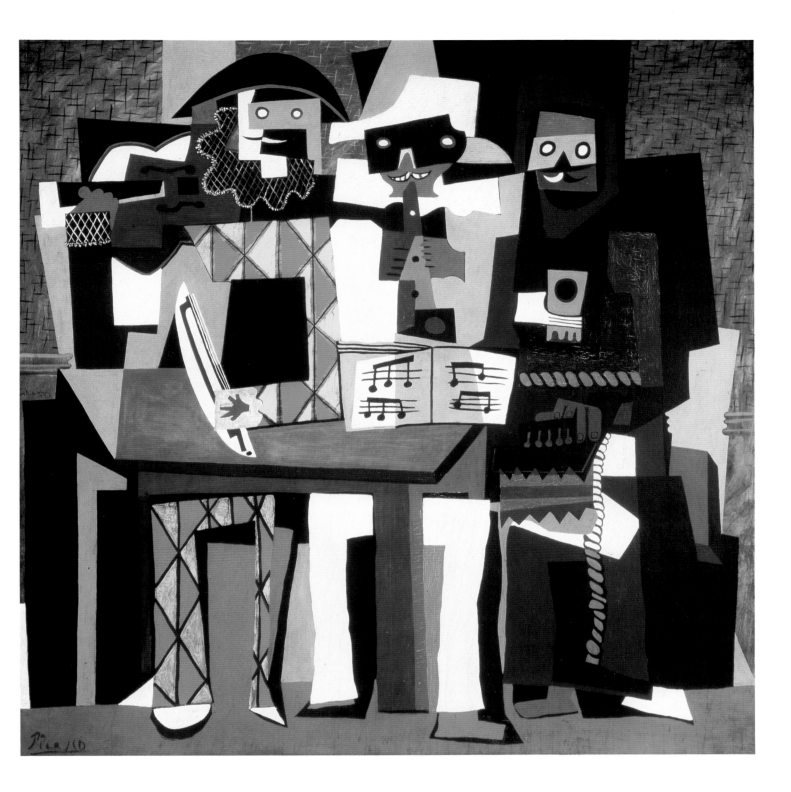

JUAN GRIS (1887–1927)
The View across the Bay

1921. Oil on canvas, 65 x 100 cm. Musée National d'Art Moderne, Centre Georges Pompidou, Paris

This work was executed at Bandol-sur-Mer on the Mediterranean, where Gris stayed from the end of 1920 until June 1921 because of his poor health. From this time on he was increasingly dogged by illness and was forced to take regular convalescent trips, though his health declined sharply in 1925–6, resulting in his death in January 1927.

In a letter to Kahnweiler Gris claimed that this painting was the best he had done while in Bandol-sur-Mer. It takes up the theme he had begun with *Still Life before an Open Window: Place Ravignan* (Plate 35), though here the integration between interior and exterior is more complete. The water of the sea and the surface of the table overlap, so that the sailing boat on the right is as much on the table as in the water, and similarly the guitar seems to be half in the water. The curved forms of the guitar echo those of the hills in the background, and the lines on the sheet music resemble the guitar strings and the waves of the sea. The inclusion of musical elements indicates the order and harmony of art, qualities also suggested by the rhythmical structure of the forms and colours. Though appearing to be entirely calm and serious, there is also a humorous element in the work. The heading of the paper on the left has the words 'Le pet' meaning 'fart' in French, making a crude joke in relation to both the sailing boat moving across the water and the musical elements. This is a reminder of the fact that from 1907 to 1914 Gris had worked as a caricaturist and illustrator.

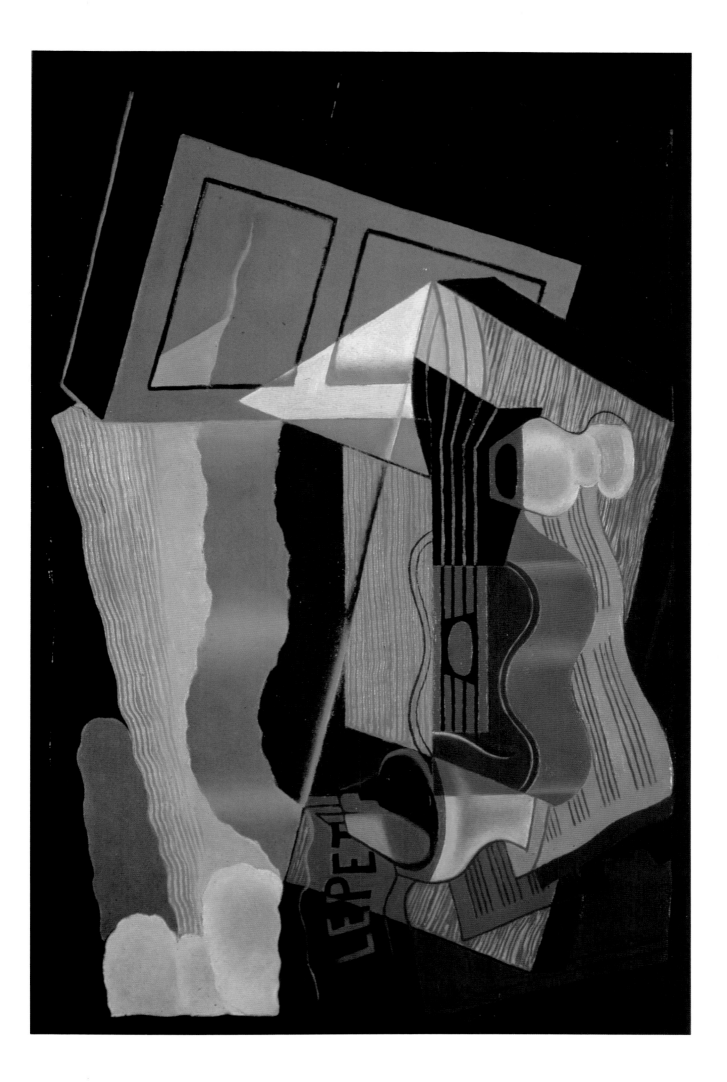

STUART DAVIS (1892–1964)
Lucky Strike

1921. Oil on canvas, 84.5 x 45.5 cm. Museum of Modern Art, New York, NY

Between 1909 and 1912 Davis studied at the Robert Henri School of Art in New York. Henri was the leader of the Realist Ashcan school, whose exponents specialized in neglected scenes of urban life, and Davis's own early paintings were of this type. In 1913 he contributed to the important Armory Show, which consisted of modern works from both Europe and America. This had a great effect on his art and he soon became influenced by the paintings of Gauguin, Van Gogh and Matisse. Although there had also been Cubist works on display, he did not explore the movement until the 1920s.

Lucky Strike is one of the four works from the 'Tobacco' series, and illustrates the eccentric slant Davis gave to Cubism. Each of the four pictures focuses on the packaging of either tobacco or cigarette papers, this one depicting the former. Davis thought such subjects especially suitable for the modern artist, writing in his notebook: 'Don't emotionalize. Copy the nature of [the] present – photography and advertisements; tobacco cans and bags and tomatoe [sic] can labels.' The Cubist device of flattening out objects is here achieved by showing the tobacco packet as if it were opened up and laid out flat in its original state. The design and typography of the packing are so carefully reproduced as to make the work seem like a *papier collé*.

While the French Cubists had also used consumer imagery, either in paintings or in *papiers collés*, they never did so to such a dominant extent. In spirit Davis's detached, meticulous reproduction of mass-produced consumer objects presages Pop art in precisely the form it took in America.

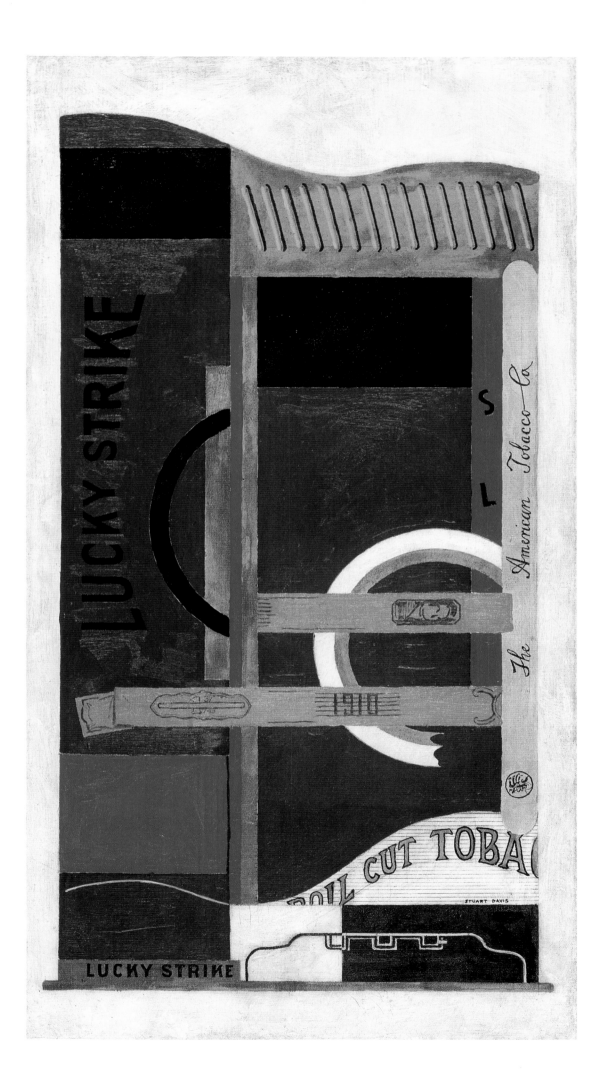

GEORGES BRAQUE (1882–1963)
Fruit on a Table-cloth with a Fruit Dish

1925. Oil on canvas, 130.5 x 75 cm. Musée National d'Art Moderne, Centre Georges Pompidou, Paris

Fig. 36
GEORGES BRAQUE
Still Life on a
Pedestal Table
1929. Oil on canvas,
146 x 114 cm.
Phillips Collection,
Washington DC

Braque was called up in 1914 and the following year he was wounded in the head. Having been left for dead he was taken off the battlefield to hospital only the following day and was then trepanned, spending two days in a coma before coming round on his birthday. He was demobilized in 1916 and in January 1917 a banquet was held to celebrate his recovery. The trauma of war and the break of almost three years from his art left him somewhat behind the developments made by Picasso, Gris and others. Further, he was no longer in close contact with Picasso and so in the post-war period he worked more independently, though still relying heavily on Cubism.

This canvas is one of Braque's masterpieces of the 1920s and is typical of the numerous still lifes on pedestal tables that he painted at this time and later (Fig. 36). The still life itself shows his recently developed technique of setting objects on a black background and then outlining them in white so that a film of black is enclosed around the surface. The effect here is to isolate and emphasize the fruit on the table-cloth. The still life with fruit, fruit bowl, glass, bottle and cittern (a stringed instrument) is executed in a broadly naturalist manner, while the treatment of the table and interior draws heavily on the techniques of *papier collé*. The background wall consists of large flat planes of marble effect in a rich green colouring, while a similar plane intrudes at the lower left. Possibly this latter element explains the alternative title for the work, *The Marble Table*, even though the table-top is certainly wood, as shown by the edges revealed beneath the table-cloth. This oddly located plane is displaced from the background where it should logically be and arbitrarily added to the foreground, so confusing the reading of space in the usual Cubist manner. The total effect of the work is seductively sensual, the materials and textures of the wood, marble and fruit being carefully recreated within a gorgeous colour scheme.

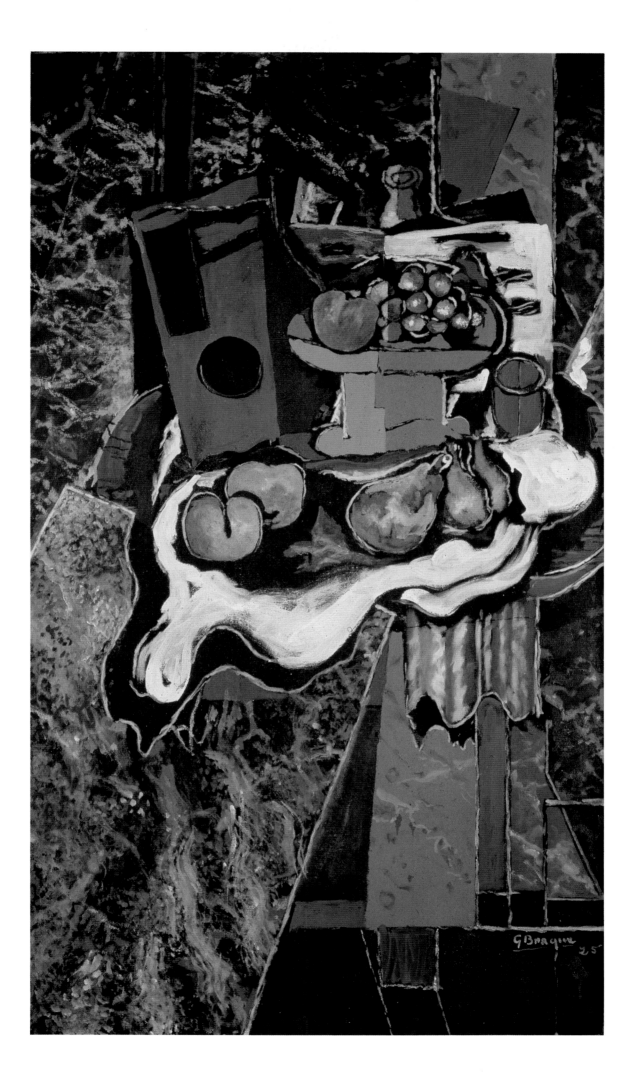

AMÉDÉE OZENFANT (1886–1966)
Still Life with Jug

*c*1925. Oil on canvas, 50 x 61.5 cm. Private collection.

This work is a typical example of Purist painting as practised by its two main exponents Ozenfant and Jeanneret (more commonly known as Le Corbusier). The ideas of Purism were expressed first in their *After Cubism* (1918) and then through the issues of the journal *L'Esprit Nouveau* (1920–25), which they jointly edited. The final summation of their theories was *Modern Painting* (1925). At the time of *After Cubism* Ozenfant and Jeanneret believed art to have become romantic, undisciplined and decadent and they consequently proposed Purism as a return to a more classical, ordered aesthetic. Though admiring the analytical phase of Cubism, they disliked its subsequent development, especially its more expressive, sensual qualities. Nevertheless, they inherited much from it, including the use of flattened space, geometry, the restricted palette of early Cubism and even the subject-matter of Montmartre Cubism.

Ozenfant and Jeanneret painted numerous images like the one shown here: still lifes with a limited range of objects, such as bottles, glasses, jugs and so on. These favoured objects were termed 'typical objects' and were seen by them to embody the law of efficiency and function with which nature had endowed man. Seeing man in mechanized terms, they tended to select those objects that were machine made. Also characteristic of Purism is the emphasis on form, which is the most important concept, as it is devoid of the distasteful, sensual aspect that accompanies colour. Hence, while the colour range of this work is limited, the formal qualities are highlighted by the strictly geometrical lines and precise modelling, features that further reflect machine ideals.

Purist paintings bear some similarities to the contemporary work of Gris and especially Léger, but neither of these artists took so strict and formulaic approach to their work. Though presented as a great, logical step beyond Cubism, Purism was short-lived and essentially an artistic dead end, the writings being of more consequence than the art. It does, however, illustrate the way in which artists were trying to move away from Cubism by this date.

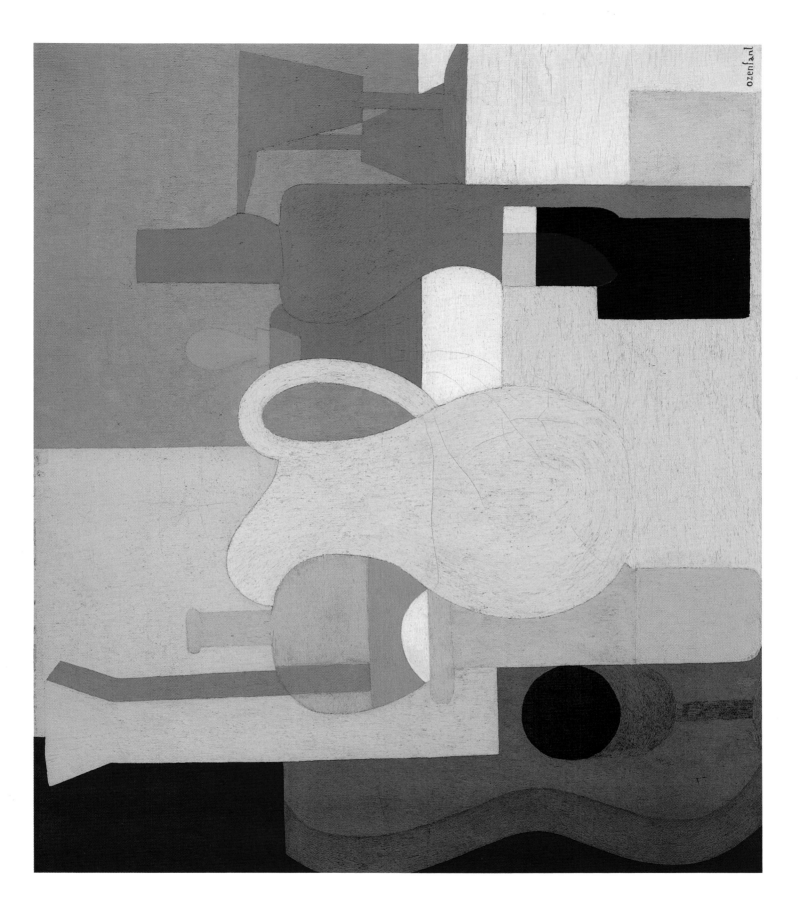

48 BEN NICHOLSON (1894–1982)
Trendrine 2

1947. Oil on canvas, 38 x 37 cm. Phillips Collection, Washington DC

Born too late to be a part of its original development, Nicholson became aware of Cubism in the 1920s when he made several trips to Paris on his way to and from Lugano in Switzerland, where he had a villa. During one of these trips he saw a synthetic Cubist painting by Picasso, which he later claimed to have been a 'real revelation...very potent and absolutely real'. It is an indication of the contemporary state of British art that he thought the work completely abstract: the short-lived Vorticist movement had done little to alter the basic perception and understanding of art.

During the 1920s Nicholson alternated between a Cubist inspired style and a naïve and rough, 'primitive' one, both of which were attempts to break away from the polished technique taught to him as a young man. In the 1930s he produced an elegant series of geometric abstract paintings and low reliefs and was also involved in the international development of this aesthetic. However, a trip to Cornwall in 1939 revived his interest in both landscape and colour, as seen here. This painting can be related to the still lifes before open windows by Gris (see Plate 35), in which the background is broadly naturalistic, while the foreground still life is Cubist. Hence, the still life is built up using the abstract planes of synthetic Cubism and executed in pale, restrained colours, while the background has both naturalistic colouring and form. The treatment of the buildings is reliant on single-point perspective, the whole landscape receding into the distance. The muted earth colours and classical balance of this work accords well with the spirit of French Cubism.

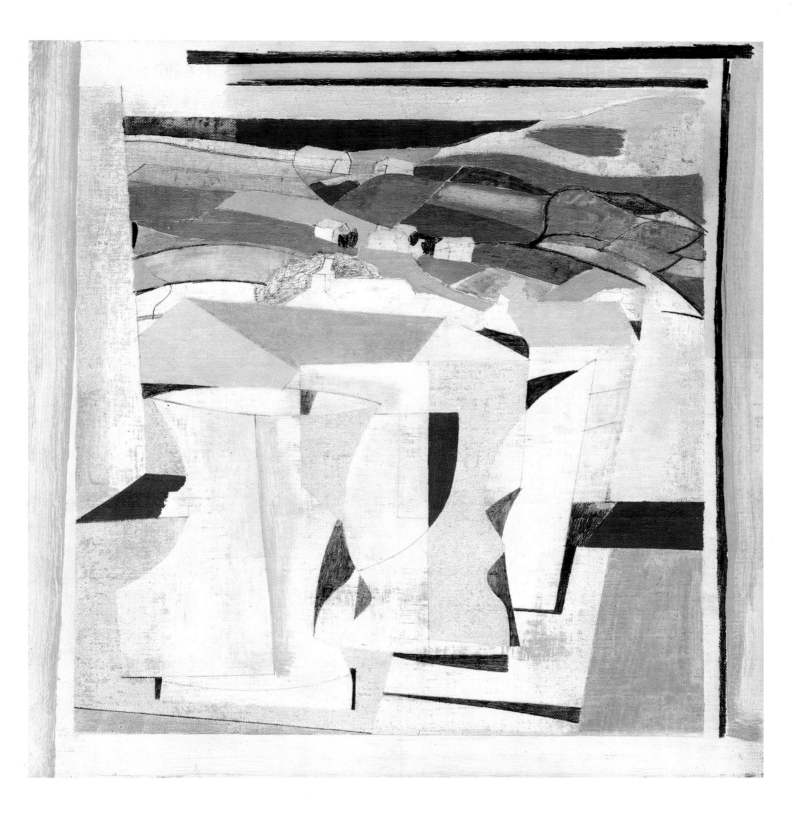

PHAIDON COLOUR LIBRARY
Titles in the series

FRA ANGELICO
Christopher Lloyd

BONNARD
Julian Bell

BRUEGEL
Keith Roberts

CANALETTO
Christopher Baker

CARAVAGGIO
Timothy
Wilson-Smith

CEZANNE
Catherine Dean

CHAGALL
Gill Polonsky

CHARDIN
Gabriel Naughton

CONSTABLE
John Sunderland

CUBISM
Philip Cooper

DALÍ
Christopher Masters

DEGAS
Keith Roberts

DÜRER
Martin Bailey

DUTCH PAINTING
Christopher Brown

ERNST
Ian Turpin

GAINSBOROUGH
Nicola Kalinsky

GAUGUIN
Alan Bowness

GOYA
Enriqueta Harris

HOLBEIN
Helen Langdon

IMPRESSIONISM
Mark Powell-Jones

**ITALIAN
RENAISSANCE
PAINTING**
Sara Elliott

**JAPANESE
COLOUR PRINTS**
J. Hillier

KLEE
Douglas Hall

KLIMT
Catherine Dean

MAGRITTE
Richard Calvocoressi

MANET
John Richardson

MATISSE
Nicholas Watkins

MODIGLIANI
Douglas Hall

MONET
John House

MUNCH
John Boulton Smith

PICASSO
Roland Penrose

PISSARRO
Christopher Lloyd

POP ART
Jamie James

**THE PRE-
RAPHAELITES**
Andrea Rose

REMBRANDT
Michael Kitson

RENOIR
William Gaunt

ROSSETTI
David Rodgers

SCHIELE
Christopher Short

SISLEY
Richard Shone

**SURREALIST
PAINTING**
Simon Wilson

**TOULOUSE-
LAUTREC**
Edward Lucie-Smith

TURNER
William Gaunt

VAN GOGH
Wilhelm Uhde

VERMEER
Martin Bailey

WHISTLER
Frances Spalding